OXFORD
OLD AND NEW

MALCOLM GRAHAM

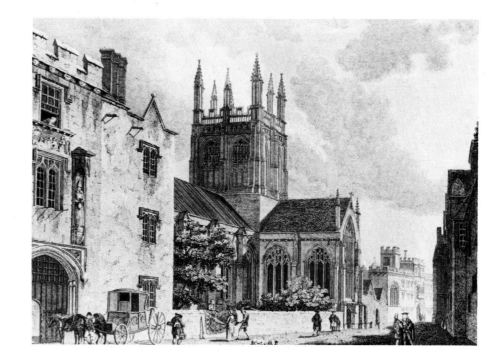

Published by EP Publishing Limited 1976

D0513222

This edition first published 1976 by
EP Publishing Limited,
East Ardsley, Wakefield, West Yorkshire
England

ISBN 0 7158 1187 8

Please address all enquires to EP Publishing Limited
(address as above)

Printed and bound in Great Britain by
Fretwell & Brian Limited, Silsden, Keighley, Yorkshire.

Introduction

In 1773, the Reverend E. Tatham, Rector of Lincoln College, published 'Proposals for the disengaging and beautifying (of) the University and City of Oxford' – plans which consisted mainly of 'opening the streets and extending the prospects'. 'At present,' he wrote, 'while the mind contemplates a part with pleasure and admiration, it labours for the incongruity of the whole, and departs disgusted and half-satisfied at best; for what it greatly approves in the University is confounded and diminished by what it greatly disapproves in the Town.'

After two hundred years, many of Tatham's vistas have been created, either for aesthetic reasons or for the convenience of traffic, and churches, University and College buildings formerly obscured by shops and houses now stand proudly revealed. In many cases, recent restoration has even added to the dignity of important buildings, and has re-captured the original intentions of their architects, whilst inevitably destroying that air of picturesque decay which crumbling Headington stone had given to so many eighteenth and nineteenth-century Oxford buildings.

The humbler buildings of Oxford Town as opposed to Gown were sacrificed for the formation of 'prospects', and have suffered also from University and commercial development in the nineteenth and twentieth centuries. Tatham spoke of the city's houses in scathing terms as 'despicable hovels', 'sorry habitations' or 'misshapen houses', objecting chiefly, one suspects, because many were gabled and timber-framed and lacked the order and regularity beloved of tidy eighteenth-century minds.

Unfortunately, this attitude was slow to die, and found echoes in twentieth-century slum clearance when buildings that would now be zealously defended fell because they had descended the social scale and rehabilitation was still unfashionable. The value of smaller-scale city houses as a foil to monumental University buildings was only gradually accepted, and growing appreciation of the nineteenth-century inner suburbs came too late to save large areas from comprehensive redevelopment, which has decanted whole communities to new estates on the city's outskirts.

The development of a huge motor industry at Cowley, and the rapid growth of Oxford's population from 49,336 in 1901 to 98,747 in 1951 catapulted Oxford to the status of an industrial and commercial centre, putting new pressure on the old city and causing it to spill over its boundaries into villages which had once been outside it. Owing to the presence of the University at its heart, much of Oxford's central area was unavailable for development, and the consequent retention of an urban population has spared it from the night-time desolation which besets so many of our nine-to-five towns and cities. Road improvements and car parks as well as new and larger shops and offices have therefore been concentrated in the western or Town side of Oxford, where the skyline changes almost every year.

Malcolm Graham
Oxford, 1976

Acknowledgements

I would particularly like to thank John Peacock for taking the modern photographs of Oxford. No doubt they will become as evocative of Oxford to-day as are the older views of Oxford in the past.

Grateful thanks are also due to the following for permission to reproduce photographs and engravings:-
 Bodleian Library 85, 97
 Oxford Mail and Times Ltd. 47, 51
 Oxfordshire County Libraries, 1, 3, 5, 7, 9, 11, 13, 15, 17, 19, 21, 23, 25, 27, 29, 31, 33, 35, 37, 39, 41, 43, 45, 49, 53, 55, 57, 59, 61, 63, 65, 67, 69, 71, 73, 75, 77, 79, 81, 83, 87, 89, 91, 93, 95.

About the Author

Malcolm Graham is Local History Librarian with Oxfordshire County Libraries. Born in Brighton, and educated at Eastbourne, Nottingham, Leeds and Leicester, he came to Oxford in 1970.

Contents

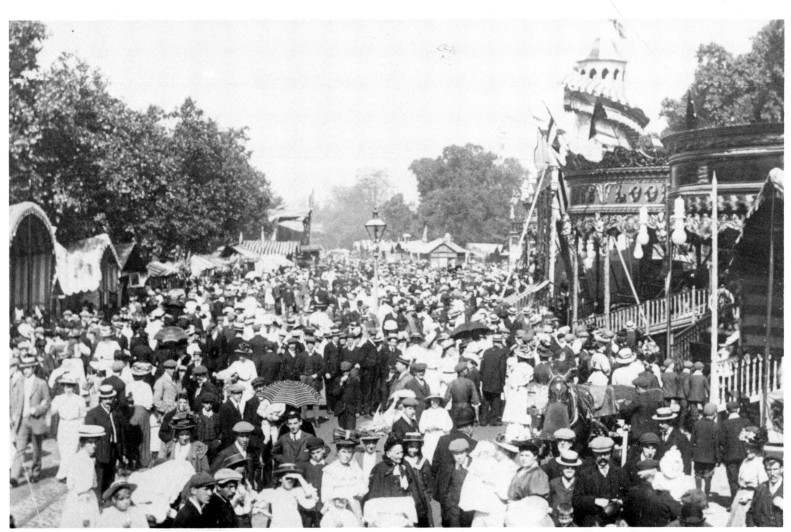

St. Giles' Fair, looking north towards St. Giles' Church - 1906
An animated scene at the heyday of the fair, when special trains brought visitors from far afield. Many women are shading their heads from the sun under large hats or umbrellas, and, almost hidden in the crowd, a man leads away a horse and cart after delivering coal for a steam-powered fairground engine out of the picture.

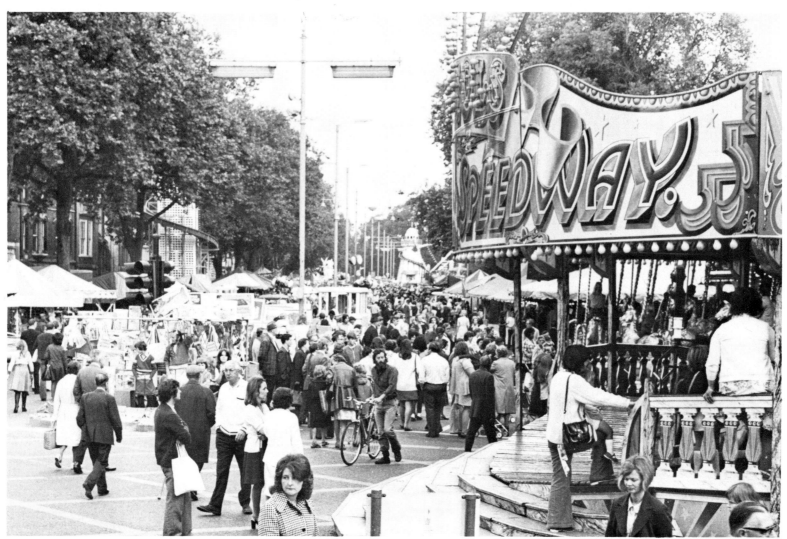

St. Giles' Fair - 1975
A similar view of this ever-popular event, which has so far survived the attempts of moralists, spoilsports and traffic managers to move or abolish it.

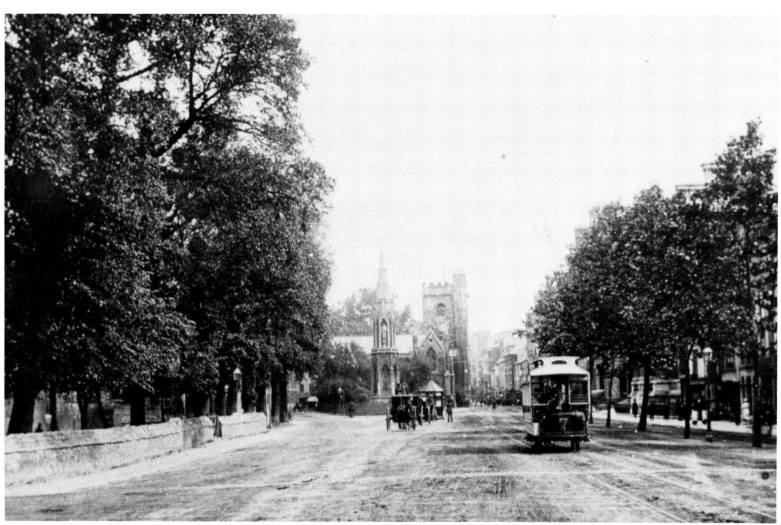

St. Giles', looking south towards the Martyrs' Memorial - c. 1882
Tramcar No. 7 journeys uneventfully towards Cornmarket Street with its passengers from North Oxford. The immaculate condition of the car suggests that the photograph was taken within months of the opening of the Banbury Road line in January 1882.

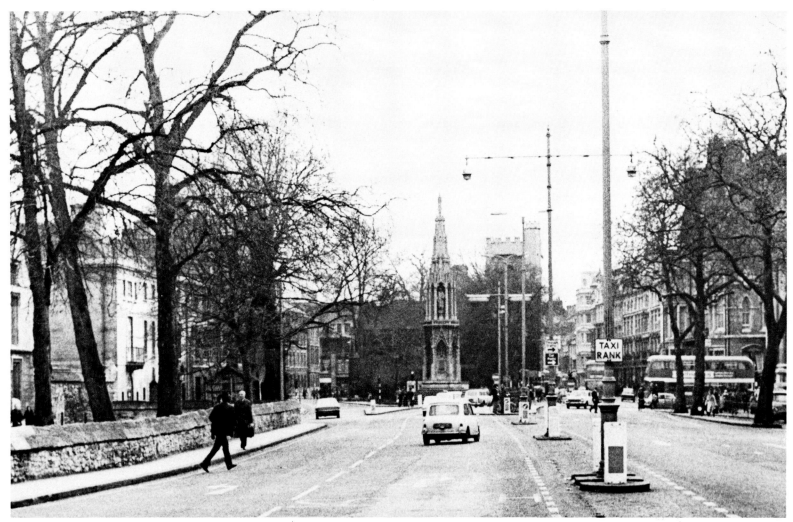

St. Giles' - 1975
Today's taxi rank in the centre of the street is an obvious descendant of the earlier cab stand, but the twentieth century has brought ever-increasing traffic and associated impedimenta, which contrast strongly with the earlier picture.

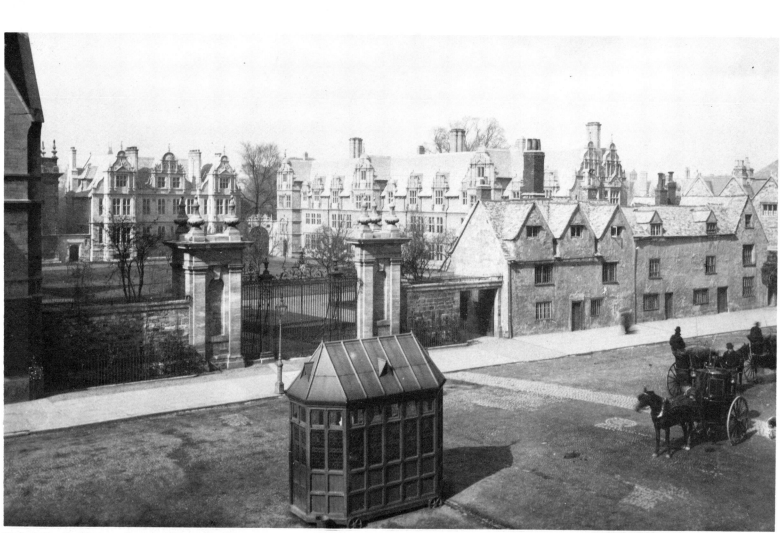

Trinity College from Broad Street - c. 1890
This shows the contemporary cabbies' hut with its wheels firmly sunk into the road surface to prevent the inevitable undergraduate prank. In the background can be seen T. G. Jackson's President's Lodgings and East Range, which were erected between 1883 and 1887 and display a variety of Elizabethan and seventeenth-century motifs.

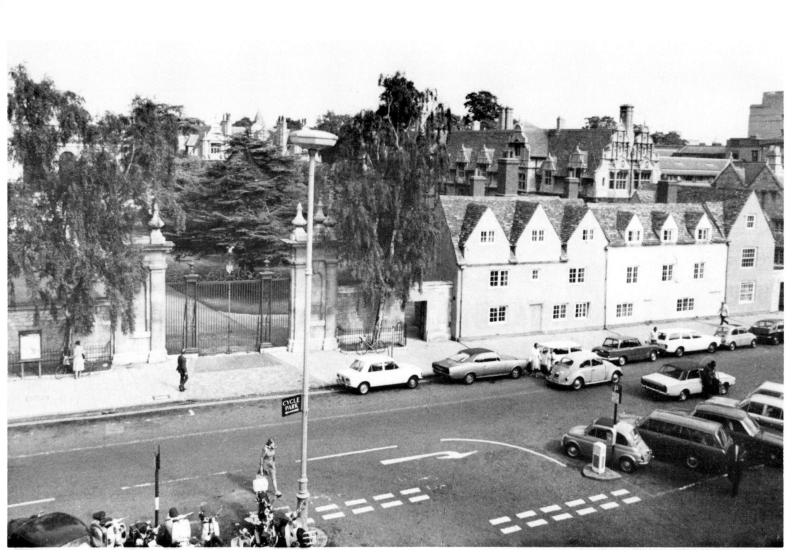

Trinity College from Broad Street - 1975
More general parking took over in the centre of Broad Street in 1928 despite aesthetic objections and a bookseller's complaint that passers-by would no longer be able to see his shop above car roofs. The seventeenth-century Trinity Cottages were reconstructed in 1969.

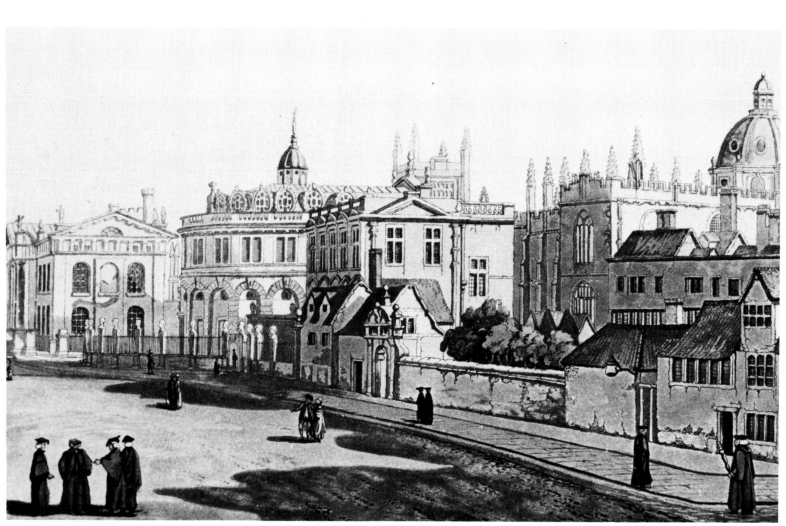

Broad Street - 1793

John Farington's aquatint shows humble seventeenth-century houses still surviving to the west of Wren's Sheldonian Theatre (1664-9) and the old Ashmolean Museum (1679-83). Next to the houses, the ornate gateway leading out of Exeter College was used by Whig voters in the 1754 Oxfordshire election, when Tory supporters tried to prevent their opponents from reaching polling booths in Broad Street.

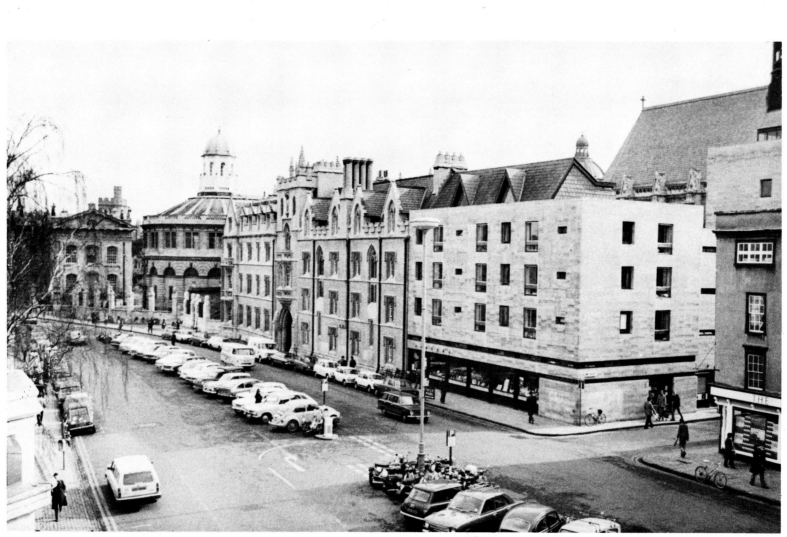

Broad Street - 1976
Exeter College broke through to the Broad Street frontage in 1833-4, when H. J. Underwood built the Gothic range east of the later tower and range by G. G. Scott (1856). The college expanded further in 1964 with the completion of the new building on the corner of Broad Street and Turl Street. Farther east, the Sheldonian Theatre lost its pretty oval dormers in 1802, and was given a larger lantern by Blore in 1838.

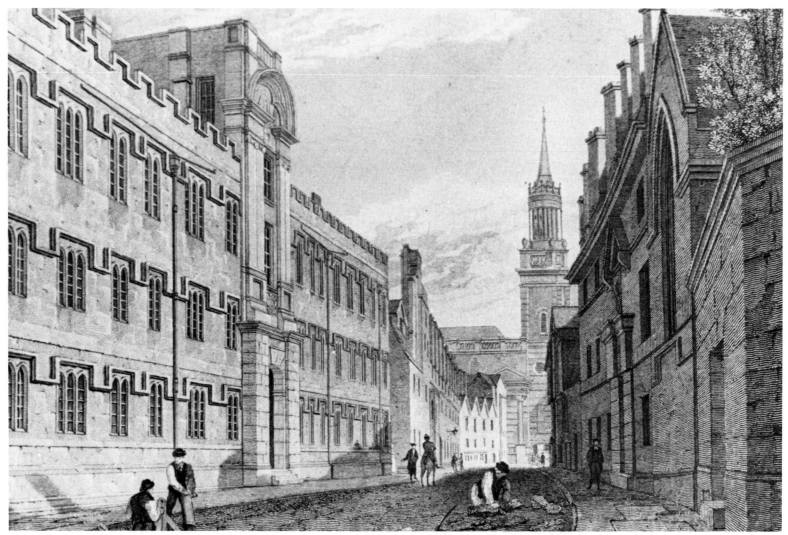

Turl Street, south of Ship Street - 1806
This drawing by J. Basire shows Exeter and Jesus Colleges with their fronts slightly modified to suit classical
tastes of the eighteenth century. Then, as now, road works seem to have been a common sight.

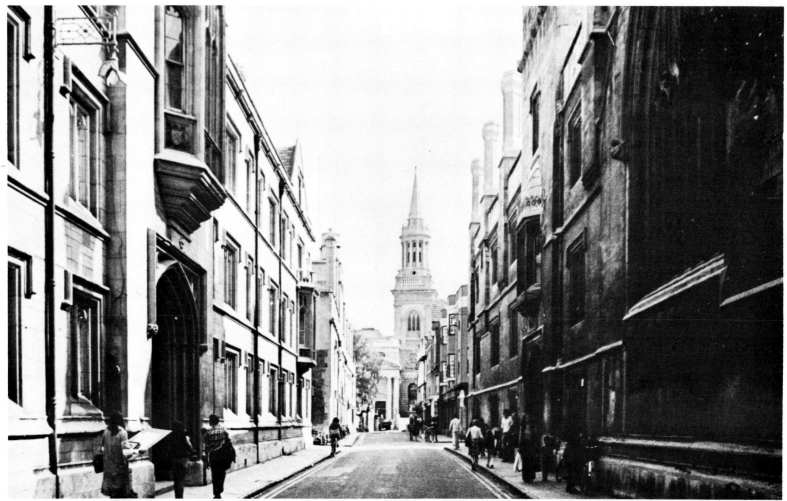

Turl Street - 1975
Both colleges returned to the Gothic fold during the nineteenth century, Exeter College being re-fronted by H. J. Underwood (1833-4) and Jesus College by J. C. and C. A. Buckler in 1854. Since the name 'Turl' is derived from a 'twirling gate' or turnstile which admitted only pedestrians, it is perhaps appropriate that most vehicles have again been excluded from the street.

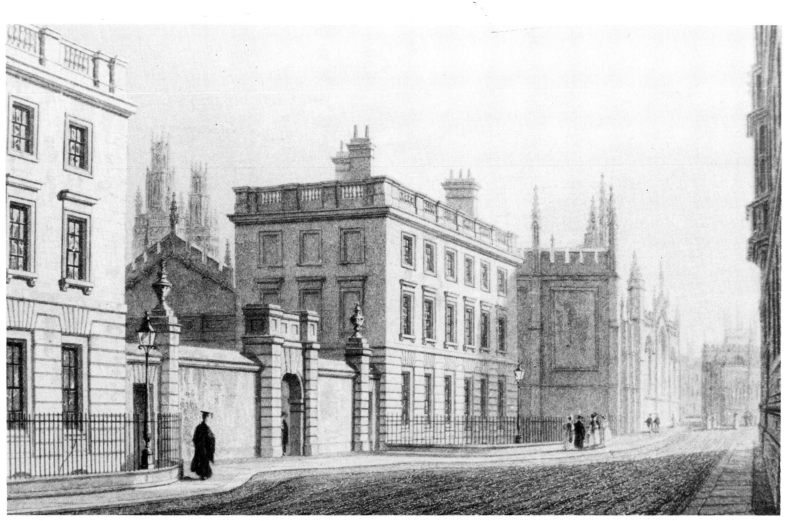

Catte Street - 1836

This view looks past Hertford College and the Bodleian Library towards All Souls' College where the west range of Nicholas Hawksmoor's North Quad was built between 1722 and 1734. Farther on, part of St. Mary's Church is visible, including the Congregation House, which dates from approximately 1320 and is the oldest University building in Oxford.

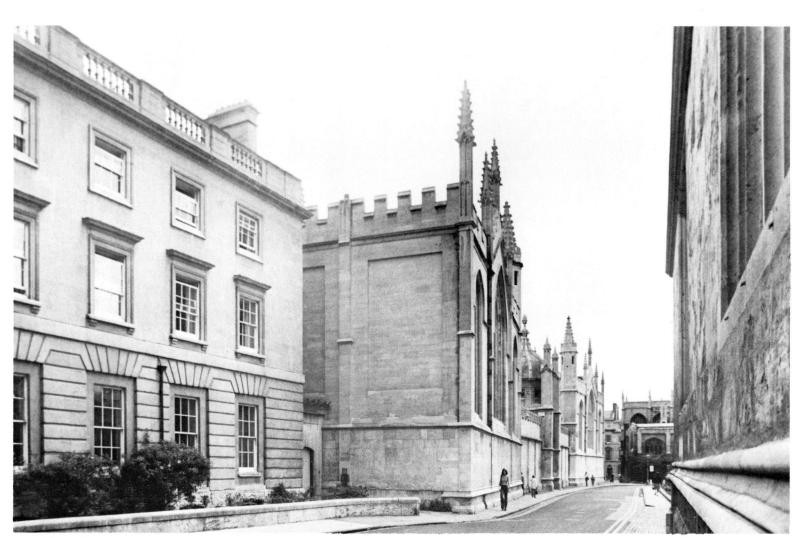

Catte Street - 1975
Until recently, Catte Street and Radcliffe Square were filled with parked cars, and pedestrians jostled with traffic in the narrow passage between All Souls' and St. Mary's Church. Since 1973, the far end of Catte Street has been closed to traffic, and parking has been heavily restricted, immeasurably enhancing the local environment.

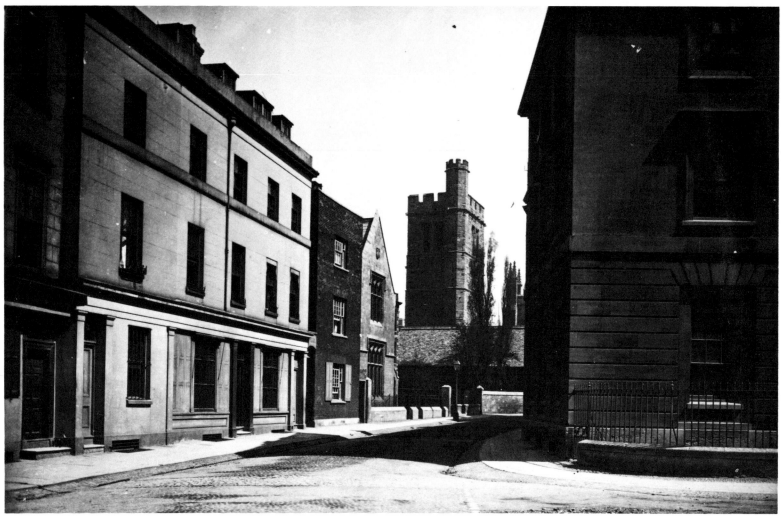

New College Lane from Catte Street - c. 1880
The view to New College tower was still open at this time. To the right of the picture is the Palladian front of Hertford College (1818-22, E. Garbett), which was built behind the street frontage of Catte Street; its imposing windows look out onto the backs of timber-framed houses which survived into the 1820s.

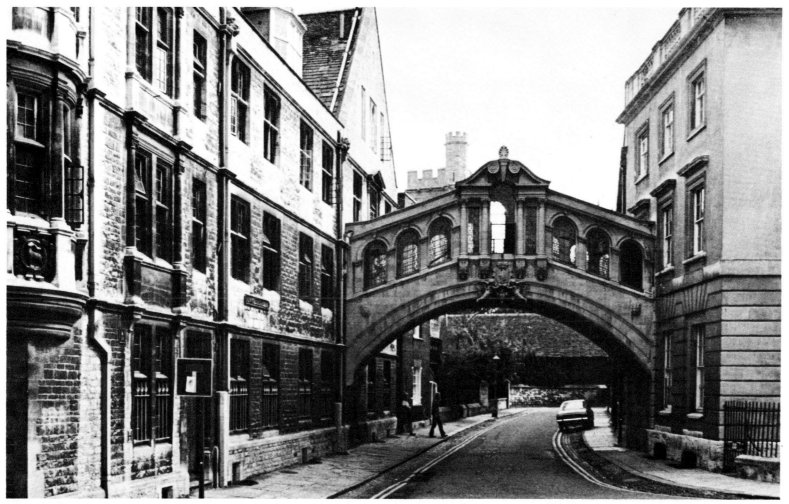

New College Lane, 1975
Oxford's Bridge of Sighs was designed by T. G. Jackson and built in 1913 to link the same architect's North Quad with the old buildings of Hertford College. Beyond the bridge, two figures may be seen emerging from St. Helen's, formerly Hell Passage, which leads through the city wall, down to houses built in the city ditch, and then back up to Holywell Street.

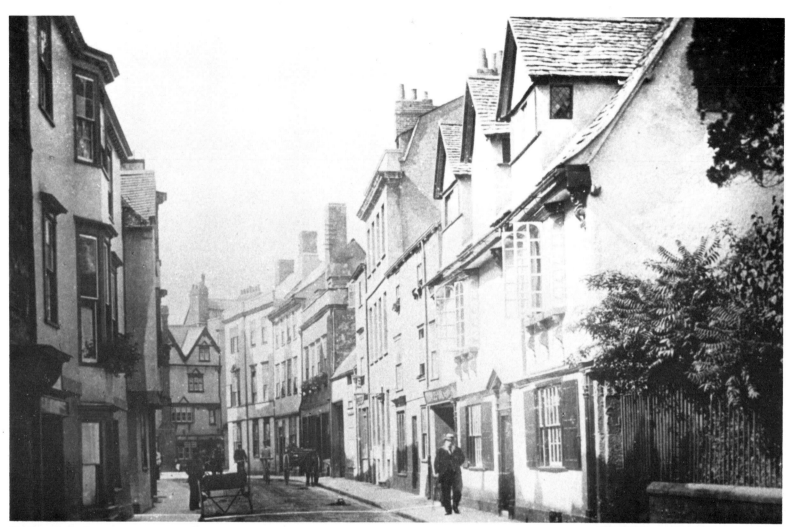

Holywell Street - c. 1895
A view of the west end, looking past no. 35, a timber-framed house of 1626 with first floor oriel windows on grotesquely-carved brackets. Modest Georgian houses lead the eye down to the King's Arms and, on the opposite side of Parks Road, the Coach and Horses public house which dated from approximately 1600.

15

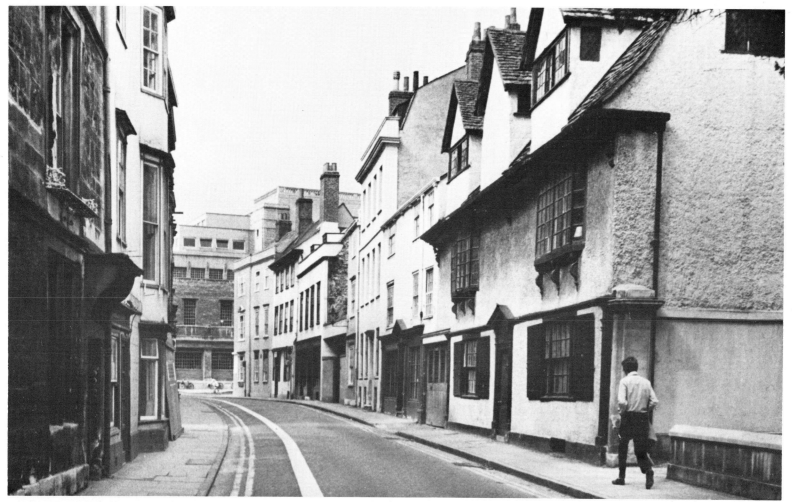

Holywell Street - 1975
The bulky New Bodleian Library (1937-40, Sir Giles Gilbert Scott) replaced the Coach and Horses, and in 1971-2, Blackwell's neatly inserted a music shop where the stables of the King's Arms had been. Very noticeable and possibly inter-related changes are the disappearance of horse manure from the street and plants from window-boxes and garden.

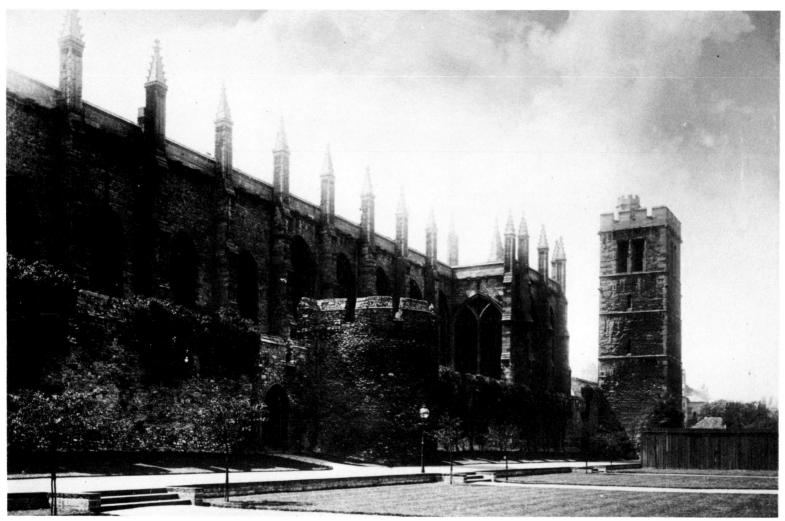

New College and the City Wall from the north-east - c. 1885
William of Wykeham's great hall, chapel and tower were built in the last twenty years of the fourteenth century, and dominate a section of the city wall which he and his successors agreed to maintain for ever in return for land which had probably been depopulated during the Black Death.

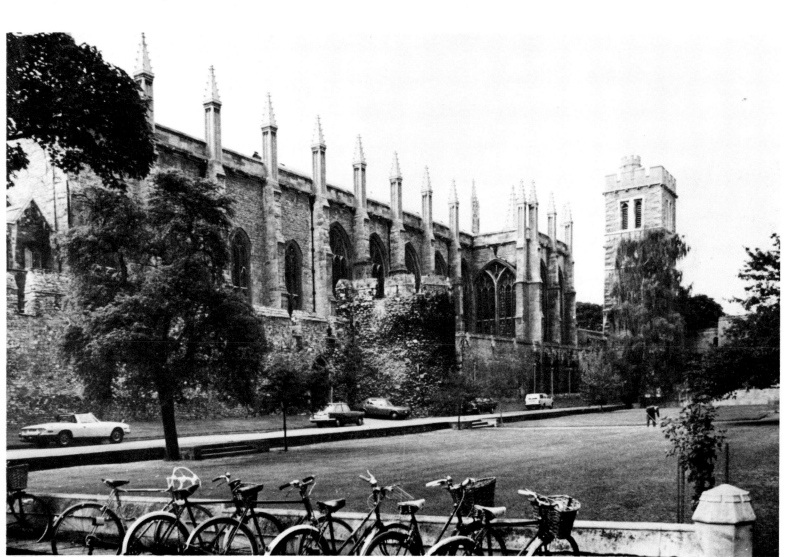

New College - 1975
Bicycles and the odd car have infiltrated the scene, but it remains basically unchanged. The city still makes regular inspections of the wall to check on its condition.

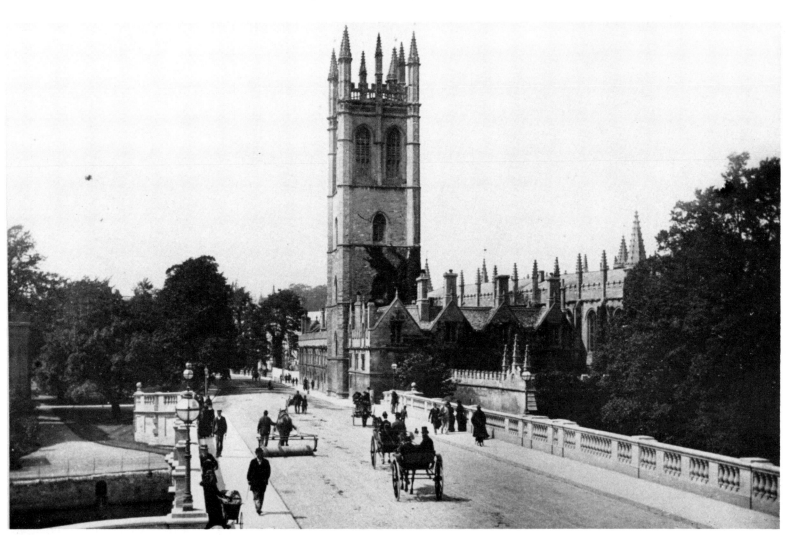

Magdalen Bridge and Tower - c. 1897
The bridge, rebuilt between 1771 and 1779, was widened by twenty feet in 1883-4 to provide room for two tramlines and a variety of traffic such as is visible in this photograph. Magdalen tower was built between 1492 and 1509, and was probably designed by the master-mason, William Reynold.

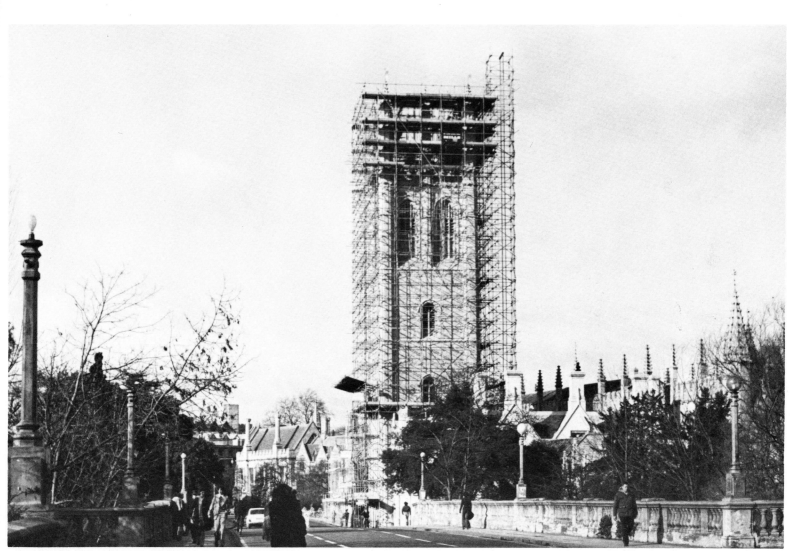

Magdalen Bridge and Tower - 1975
This photograph shows the tower undergoing one of its periodic bouts of repairs. The closure of Magdalen Bridge to all but essential vehicles has been suggested on occasions, but so radical a move has yet to find official favour.

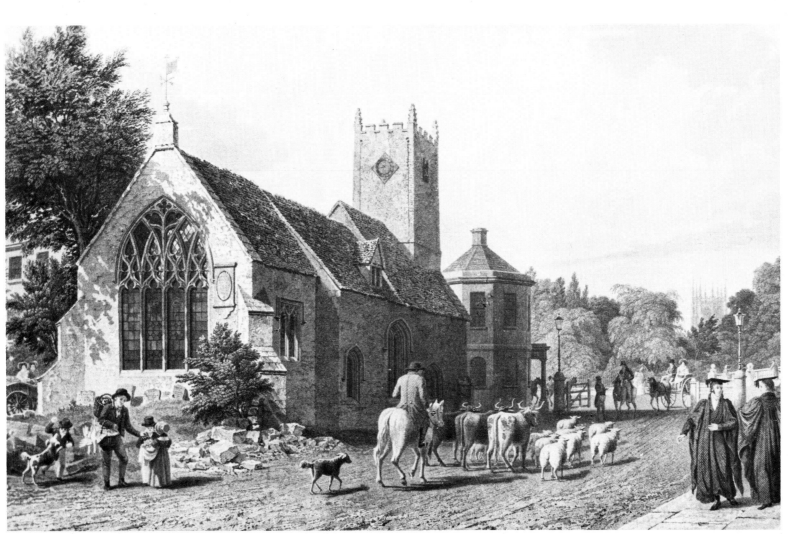

Old St. Clement's Church from the north-east - c. 1820
This engraving shows the medieval and later church with the stone toll-house of 1818 beyond it. The gate-keeper is taking money from a passing horseman, and the approach of animals for market, and other traffic, seem to be offering him little respite for the next few minutes.

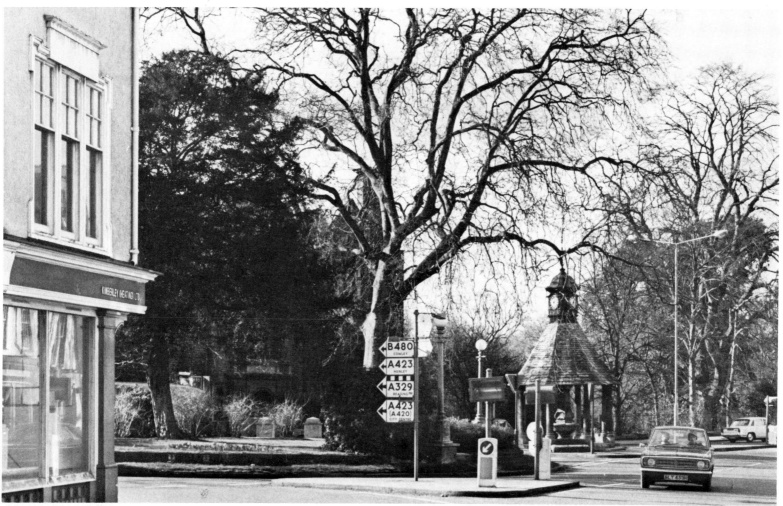

The Plain from St. Clement's Street - 1976

A new St. Clement's Church was built off the Marston Road between 1825 and 1828, and the old church was demolished in 1830. The Plain, meaning an open space in front of houses, was therefore created in what had been the heart of this small medieval suburb. The toll-house was removed in 1874, and the Victoria Fountain was built on the site in 1899.

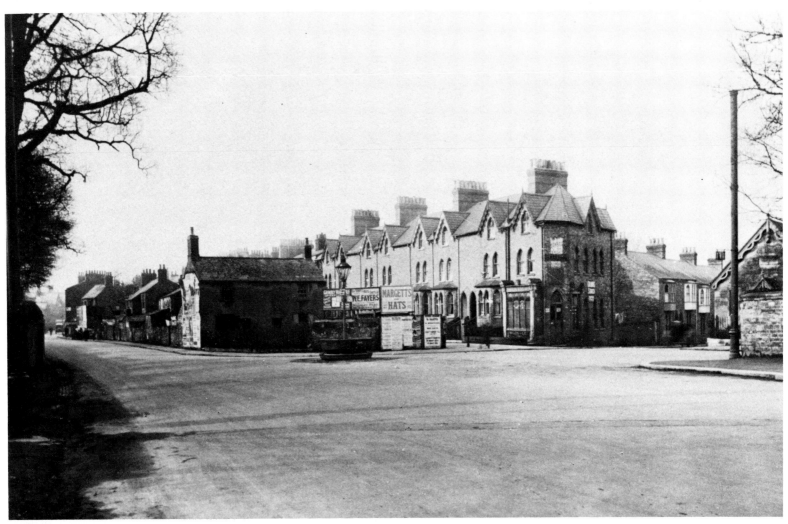

London Place - c. 1926
A view from the bottom of Headington Hill, showing the large horse trough which gave horses the chance to refresh themselves before they began the long pull up to Headington. The tall, Gothic houses in London Place were built in about 1883.

23

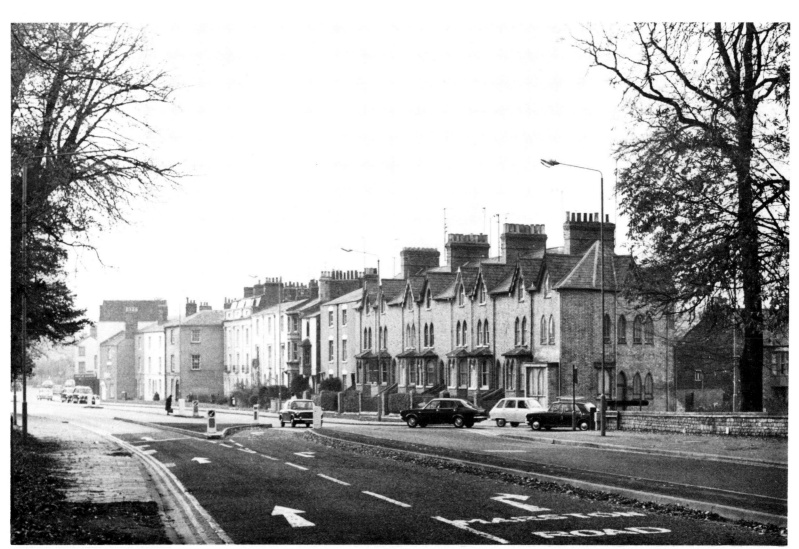

London Place - 1975
The demolition of shabby premises in front of London Place in 1927 enabled the road to be widened, and exposed to view classical style houses built during the rapid expansion of St. Clement's in the 1820s.

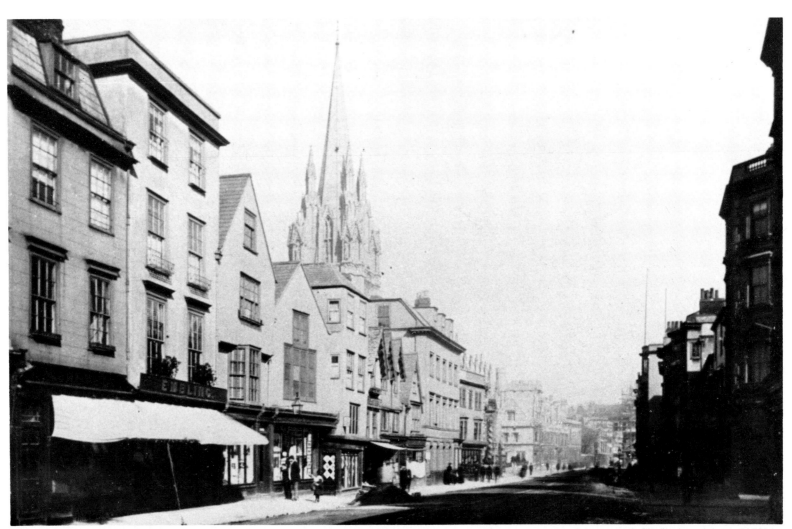

High Street, looking east towards All Souls' College - c. 1885
A charming group of seventeenth and eighteenth-century houses, some refronted or rewindowed in the 1800s.
The large windows of no. 25, two doors down from Embling's, lighted the photographic gallery of James Ryman;
Henry Taunt, who took this photograph, began his career in a shop behind no. 26 in 1856.

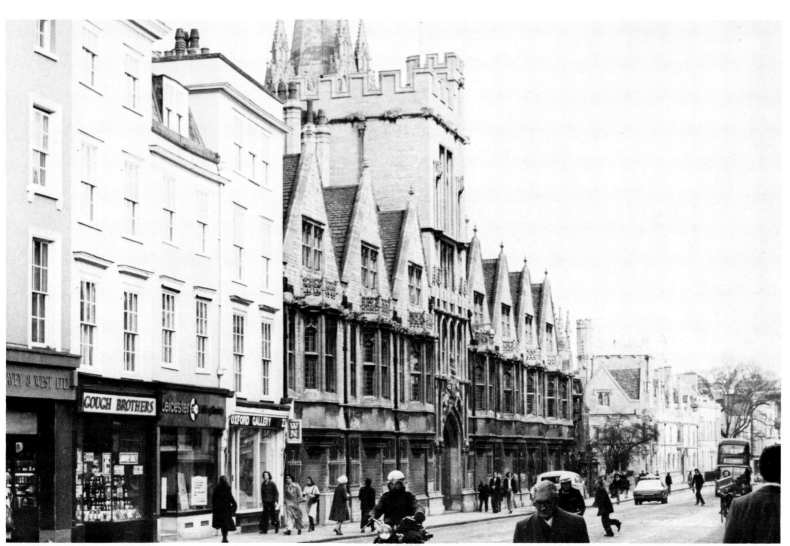

High Street - 1976
Nos. 21-23 still survive, but the houses beyond were demolished in two stages for the High Street frontage of Brasenose College, which was designed by T. G. Jackson and built between 1887 and 1909.

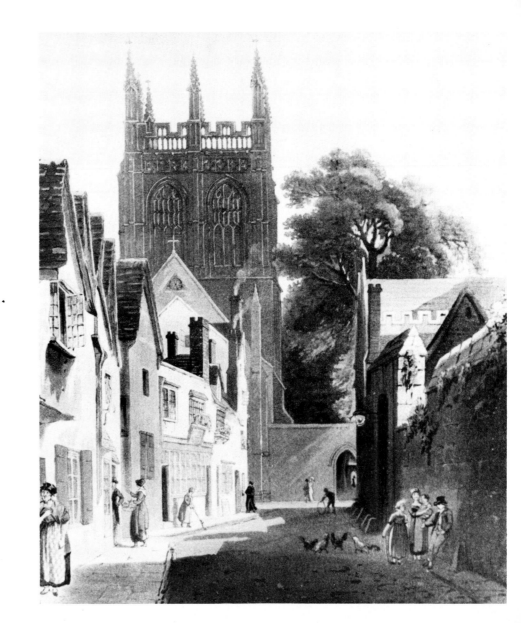

Magpie Lane - 1813
A delightful view towards the tower of
Merton College Chapel, which was
completed between 1448 and 1451. In
the foreground, a girl defies the Paving
Acts by selling from door to door,
whilst a maid is sweeping rubbish out of
the Black Lion, no doubt providing more
food for the scavenging hens.

Magpie Lane - 1975
Redevelopment of various dates is evident, ranging from the tall terrace of about 1820 in the foreground to the recent extension of Oriel College which peeps attractively through the ancient rubble wall on the right. Beyond Kybald Street, Powell and Moya designed the corner block for Corpus Christi College (1969).

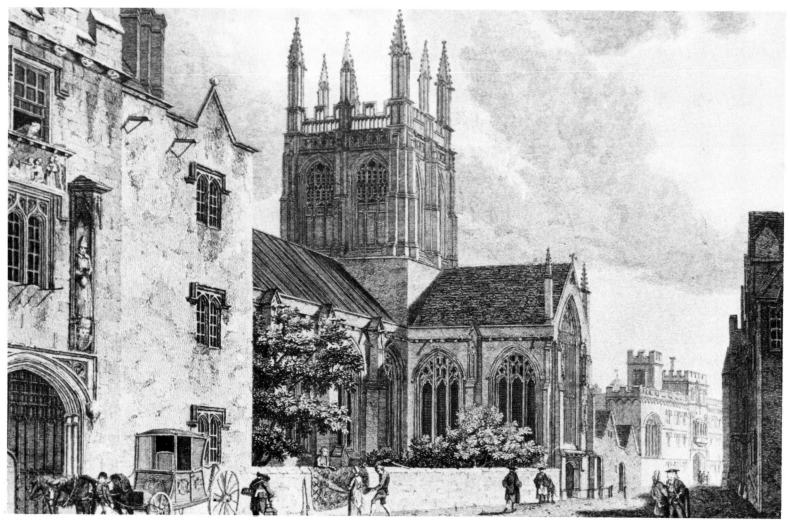

Merton College - 1772

In Rooker's drawing a coach and pair wait outside the fifteenth-century gateway for some distinguished visitor. Beyond the man with a cage, who may have been selling or exhibiting song-birds, vigorous carpet-beating is in progress.

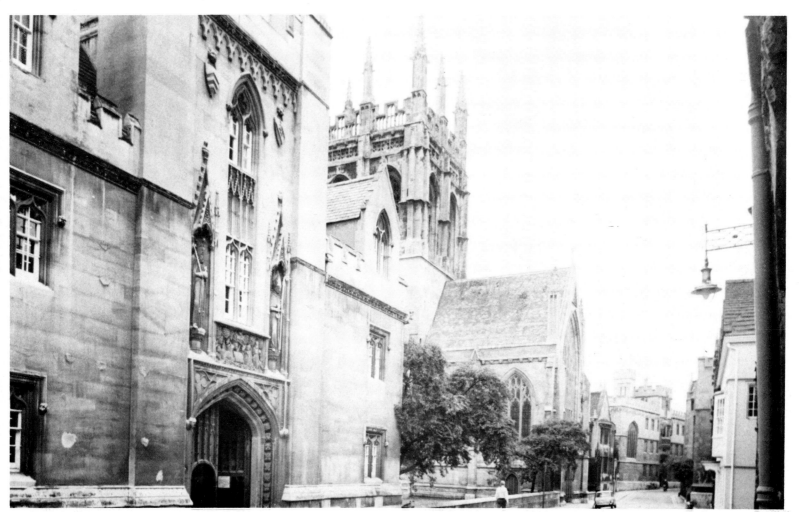

Merton College - 1975
The Merton Street front was reconstructed by Edward Blore between 1836 and 1838, and the gateway was considerably altered. The view past Merton towards Corpus Christi has changed little, however, and the cobbles have been stoutly and successfully defended against the tide of tarmac which has, at times, threatened to overwhelm them.

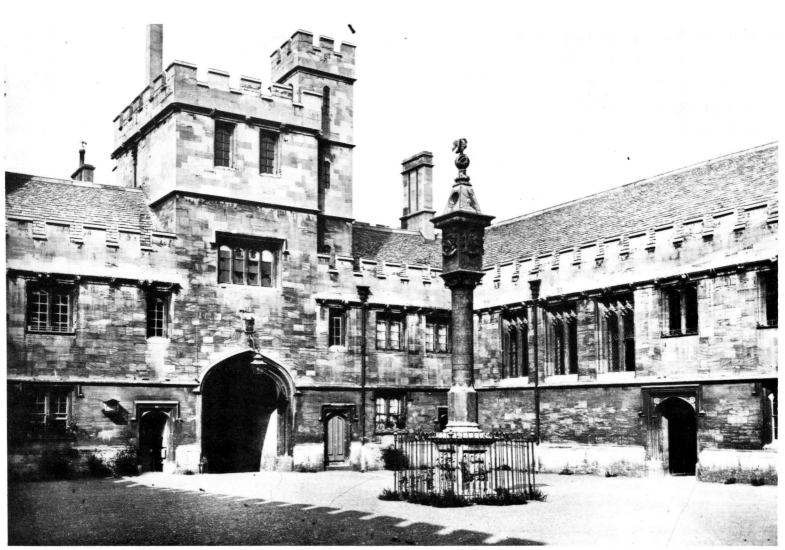

Corpus Christi College - c. 1880
Charles Turnbull designed the famous sundial surmounted by the college's pelican, which has decorated the Front Quad since 1581. The Quad itself was built in the early sixteenth century, and battlements were added in 1625.

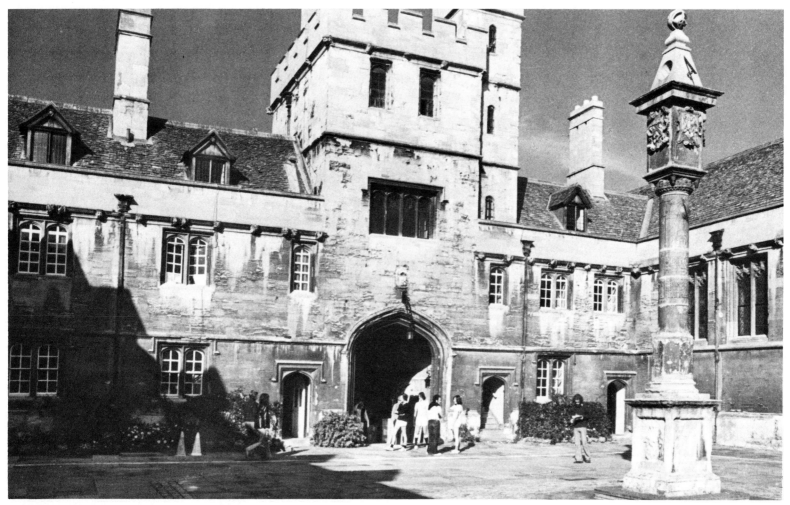

Corpus Christi College - 1975
The spread of paving or grass in college quads at the expense of gravel was long resisted at Corpus Christi, and it was only in 1972 that the Front Quad was paved. Other changes have included the insertion of dormers to light attic rooms, the recent replacement of the pelican on the sundial and the removal of the protective railings which once surrounded it.

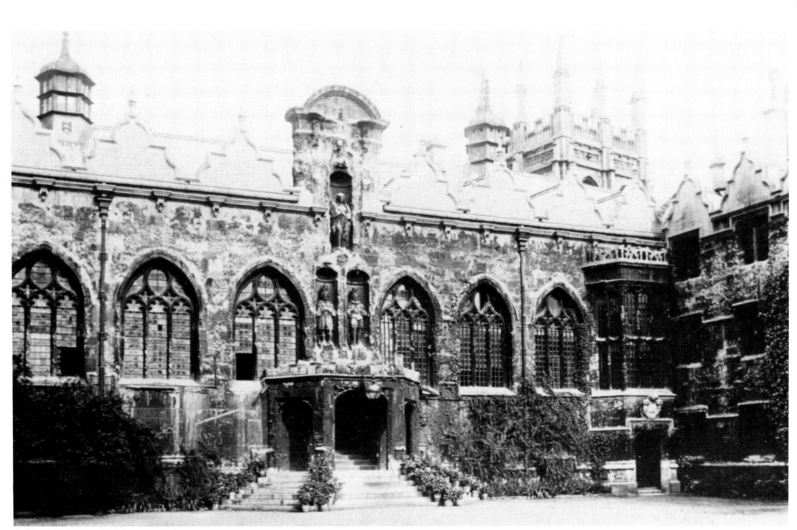

Oriel College - c. 1895
This view of the Front Quad of 1620-42 shows the damage done to inferior quality Headington stone by air pollution from the industrial and residential quarter which developed in south-west Oxford during the nineteenth century. Finer details such as the motto and decoration above the porch had entirely disappeared, and the small shaped gables had already been replaced.

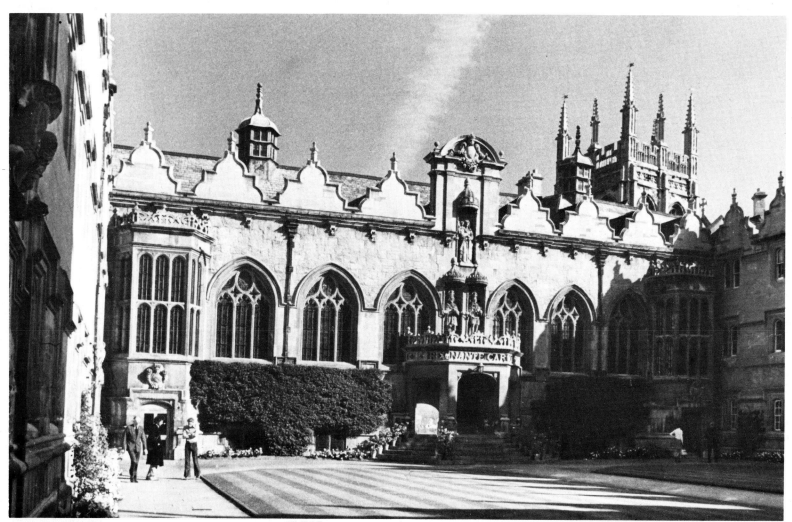

Oriel College - 1975
Like many other important Oxford buildings, the Front Quad has now undergone complete restoration. The porch, with its inscription *Regnante Carolo*, was rebuilt in 1897, and the statues of Edward II, James I, and above them, the Virgin and Child, have also been renewed.

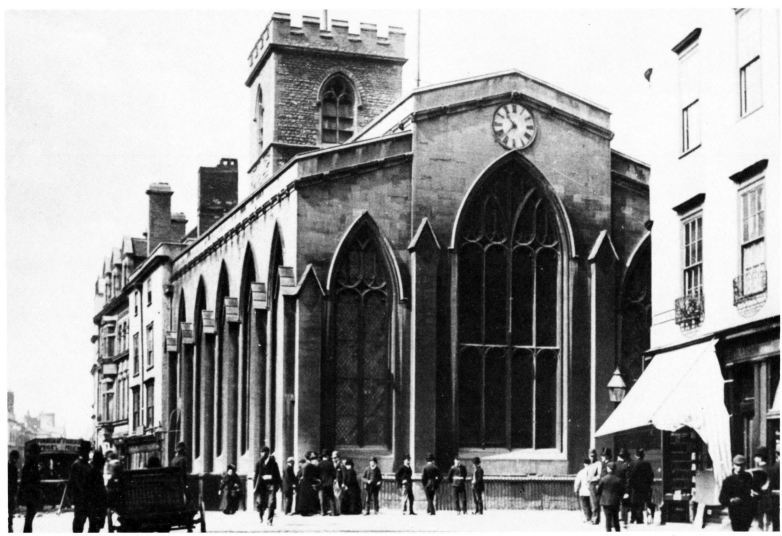

St. Martin's Church, Carfax - c. 1890
The main body of the city church had been rebuilt in 1822, leaving the fourteenth-century tower intact, and was surprisingly permitted to extend farther into the street than the old church had done.

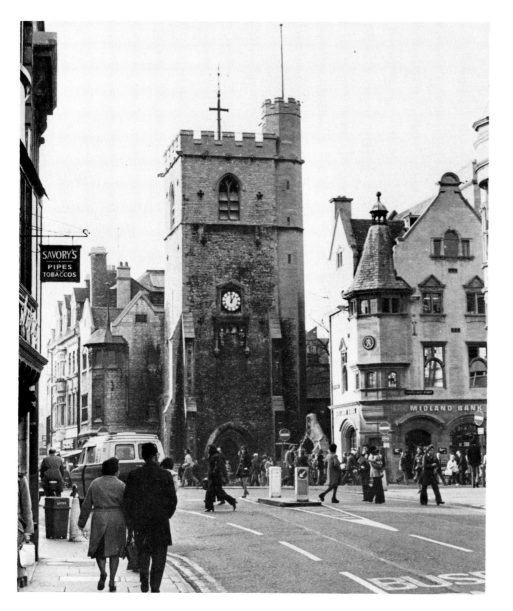

Carfax - 1975
St. Martin's Church was demolished in 1896 as part of the Carfax Improvement Scheme. The tower was again retained, and, after plans by H. T. Hare for turning it into a late Victorian civic monument had been rejected, its restoration on slightly more conservative grounds was supervised by T. G. Jackson.

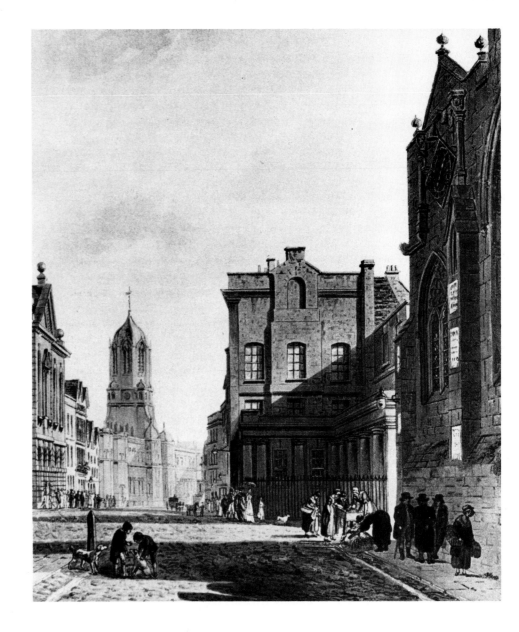

St. Aldate's from Carfax - 1813
Women are selling produce in front of
the railed-off Butter Bench of about
1710, ignoring a forty-year-old ban on
street-selling. Beyond the 1751 Town
Hall is the familar sixteenth-century front
of Christ Church which was left
unfinished at the time of Wolsey's fall
and was only completed by Wren's Tom
Tower in 1681-2.

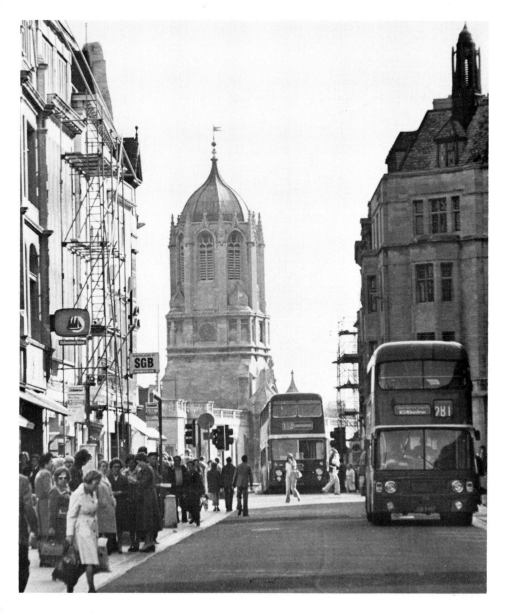

St. Aldate's from Carfax - 1975
Tom Tower still dominates the scene, but
Carfax has been totally remodelled.
Behind the no. 281 bus is Marygold
House, built in 1930-1 on the site of the
Swyndlestock Tavern, where the great
Town and Gown conflict of St.
Scholastica's Day 1355 began.

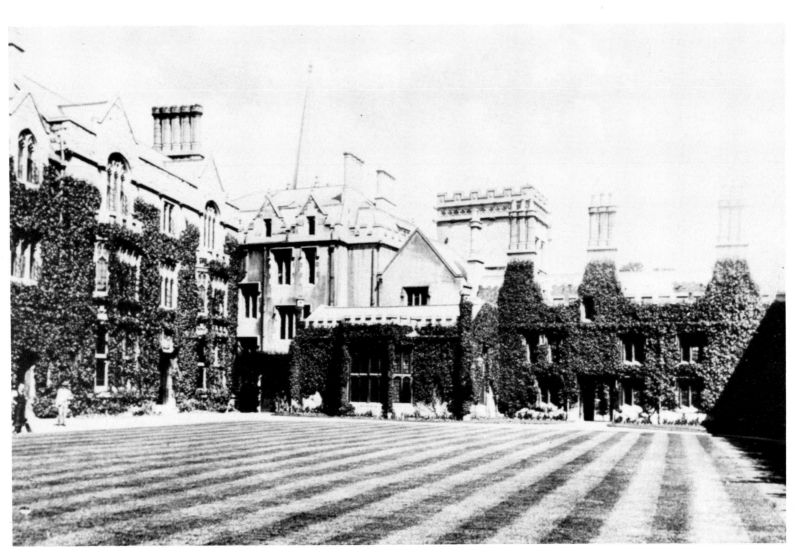

Pembroke College - 1899
A gardener leans on his broom in Chapel Quad. The north range behind him was designed by John Hayward and built between 1844 and 1848, but the east range is formed by the back of the seventeenth-century Old Quad.

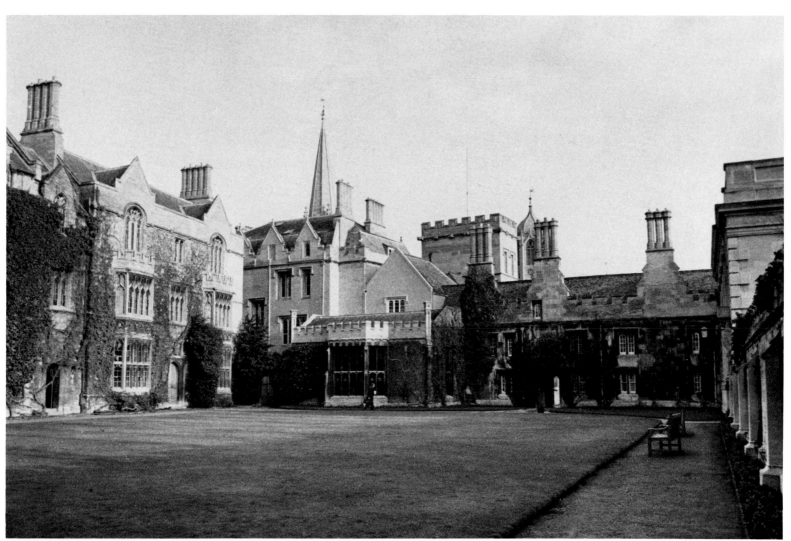

Pembroke College - 1975
Little has changed in the intervening years, and Chapel Quad is still festooned with creeper. In the background, the parapet of the Gate tower was altered by Bodley and Garner soon after 1900.

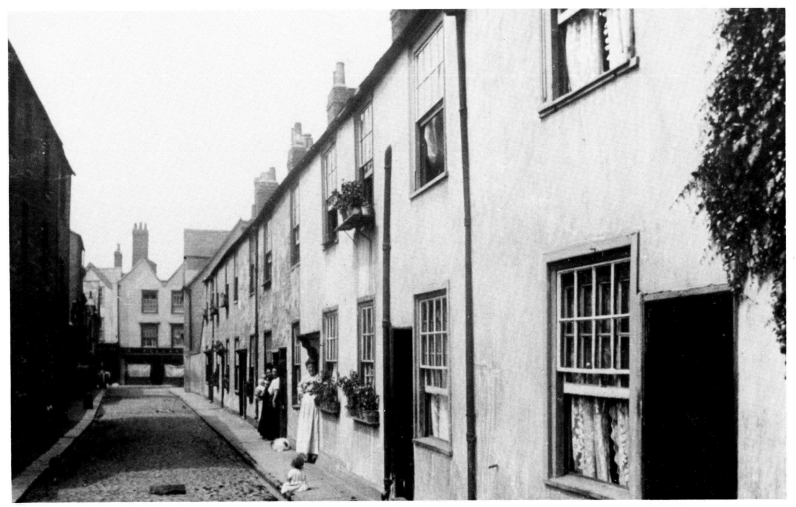

Floyd's Row, looking west to St. Aldate's - 1910
This row was one of the many early nineteenth-century speculative developments built in the back gardens of older and more substantial houses to cater for an increasing population. In spite of overcrowding and poor sanitary facilities, such houses could be neighbourly, and proud residents cheered them up by putting out window-boxes.

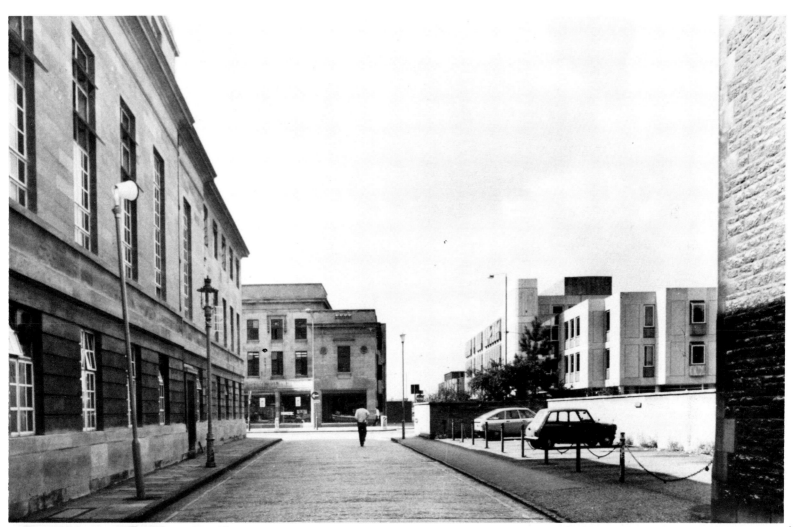

Floyd's Row - 1975
The various rows, courts and yards off St. Aldate's were demolished between the wars, and their inhabitants were dispersed to peripheral estates. Morris Garages Ltd. replaced the buildings in St. Aldate's in 1932, and, beyond the parked cars, Speedwell House was completed in 1974. On the left is Oxford Police Station, built in 1936.

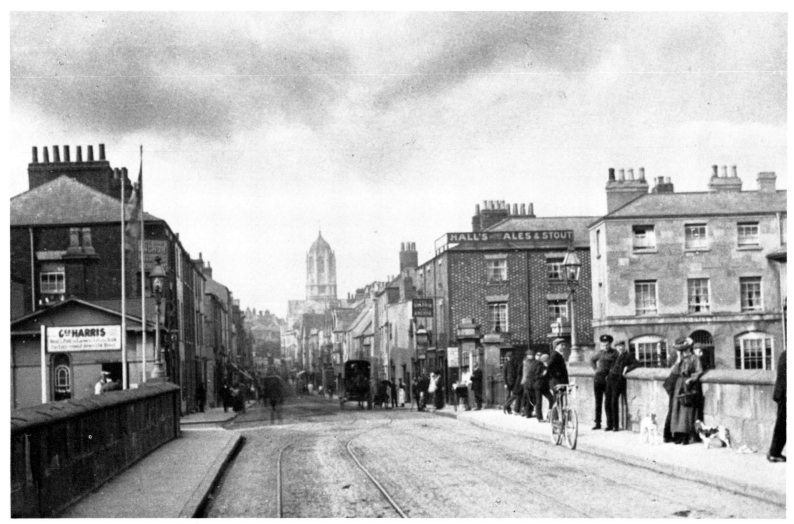

St. Aldate's from Folly Bridge - 1907
At the end of the bridge, George Harris's premises were built as a toll-house in 1844. The stone Wharf House on the right dates from approximately 1828, and, as the eye travels up St. Aldate's, brick buildings of about 1830 give way to earlier, gabled houses and then to Tom Tower.

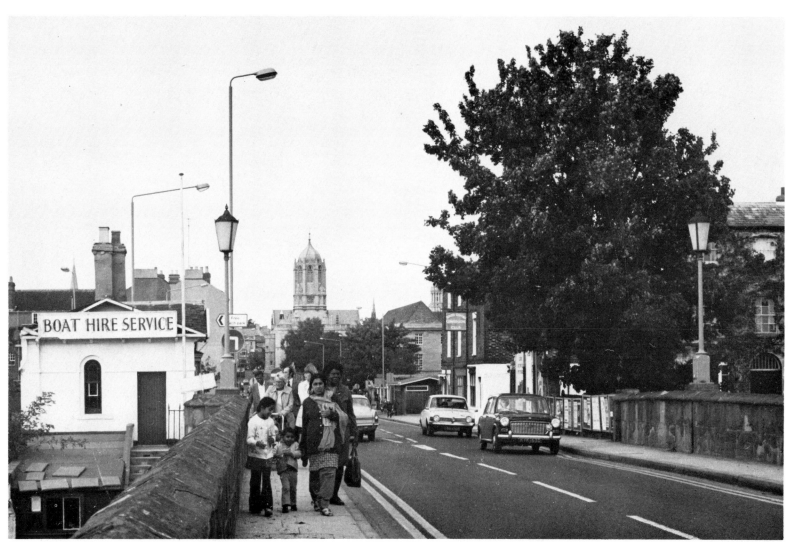

St. Aldate's from Folly Bridge - 1975
The foreground has hardly changed, but the clearance and partial redevelopment of properties farther north has reinforced the prominence of Tom Tower. The lower end of St. Aldate's is now little more than a traffic corridor.

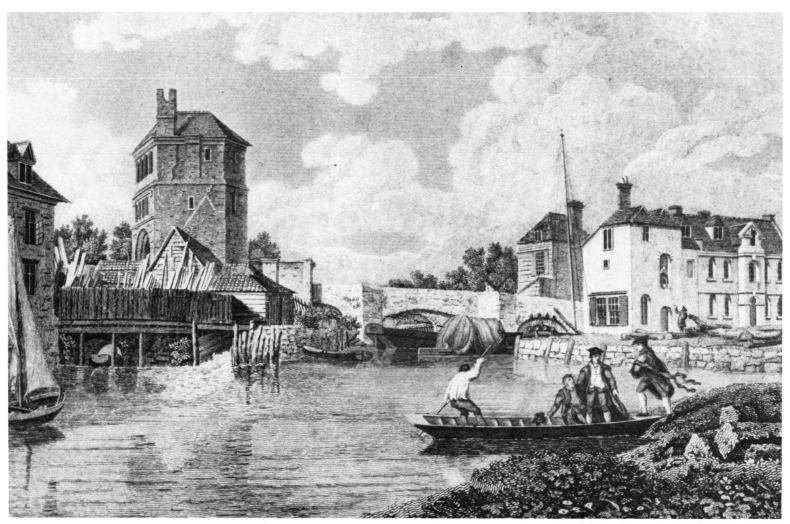

Folly Bridge from Christ Church Meadow - 1772
Skelton's engraving shows the medieval and later bridge dominated by Friar Bacon's Study, the defensive New Gate, which, converted into a house, became known as the Folly from which the bridge is named. Barges at the Wharf hint at the importance of the Thames for the carriage of goods before the railways came.

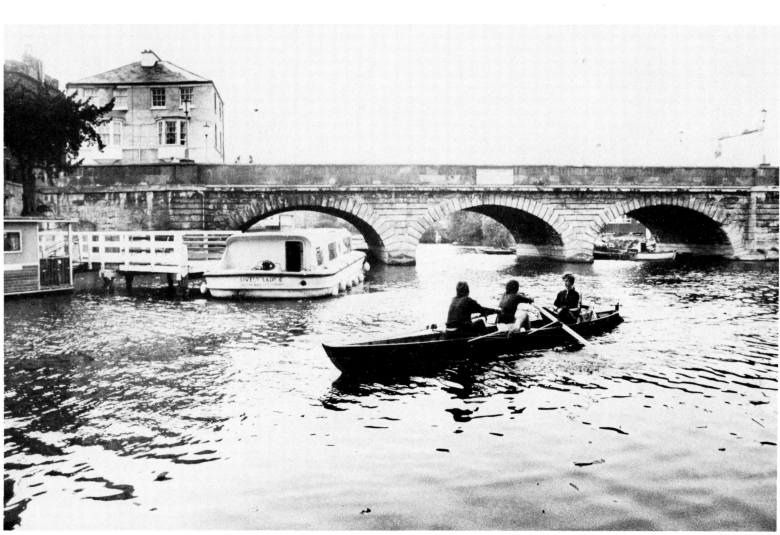

Folly Bridge - 1975
Friar Bacon's Study was demolished for road widening in 1779, and in 1815 old Folly Bridge was condemned as 'very ancient and greatly decayed . . . , very narrow and inconvenient'. It was rebuilt between 1825 and 1827 to the design of Ebenezer Perry.

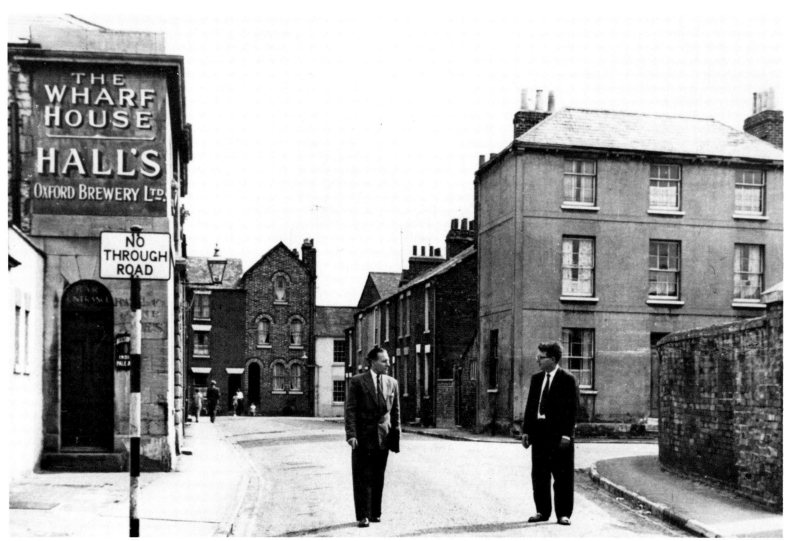

Friar's Wharf - 1959

The Wharf House public house of approximately 1830 originally stood beside the busy Friar's Wharf, but when the railways destroyed river traffic in the early 1840s, the Wharf was filled in and houses were built over the site.

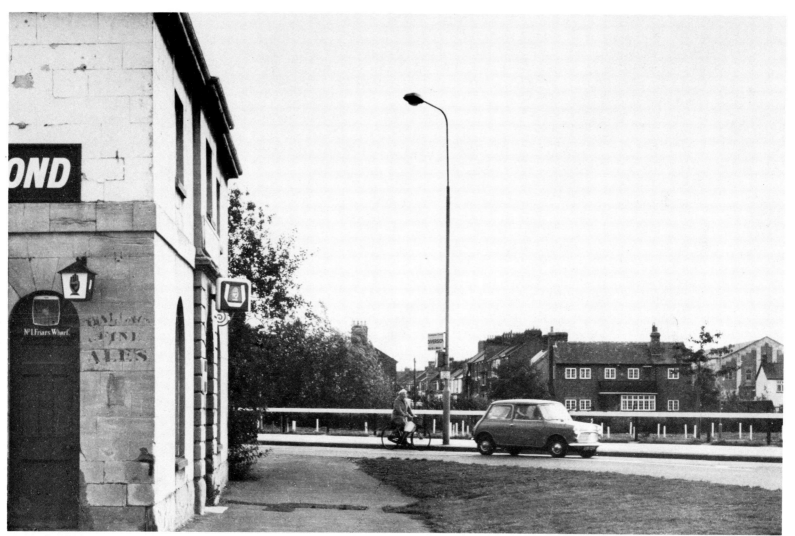

Friar's Wharf - 1975

That so many houses could have existed in a space now occupied only by tarmac and grass seems almost impossible, but the Wharf House survives to prove it on the corner of Thames Street and Speedwell Street.

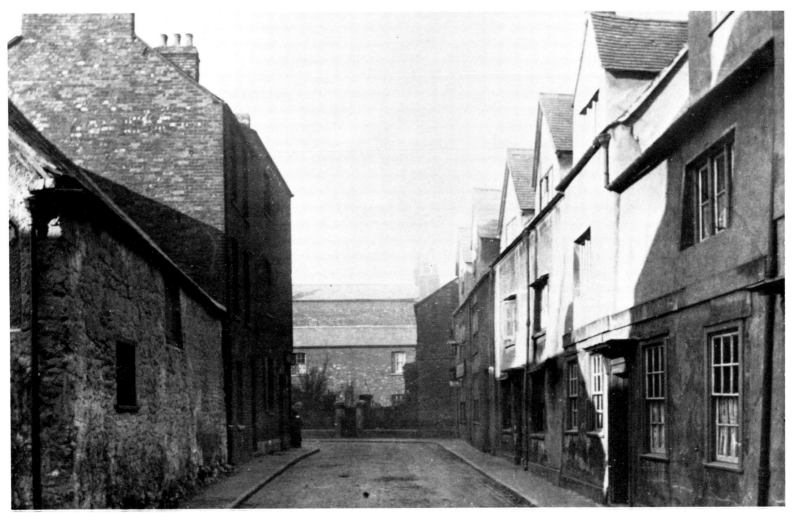

Charles Street - 1912
The rubble building on the left was probably part of the medieval Franciscan Friary, and the sudden bend in the street beyond gabled seventeenth-century houses was a mid-nineteenth-century feature, providing vehicular access to Penson's Gardens. Before that, pedestrians could walk through the inner Friary gate, but other traffic had to turn back — hence the old name for the street, Turnagain Lane.

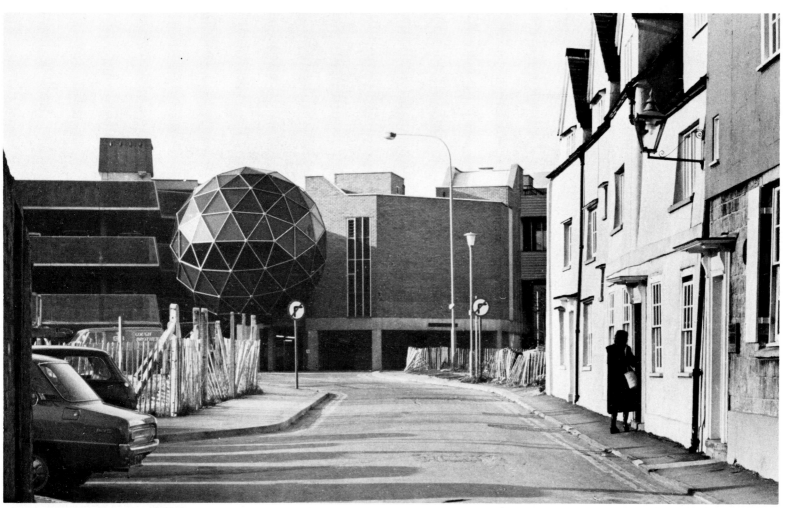

Turnagain Lane - 1975

The Oxford Preservation Trust rescued nos. 8-10 from imminent demolition in 1971, and, since the street is once again a cul-de-sac, it has reverted to its original name. Most of the street has disappeared, however, and beyond the waste-land is Oxford's most extraordinary modern building, a glass golf ball which is the control room for the Westgate multi-storey car park.

Paradise Square - 1961
Blighted for many years by the threat of demolition, the Square lapsed into sad decay. It was begun in 1838, and never quite achieved fashionable status. The central area was described as 'a desert waste' in 1851, and St. Ebbe's parish rectory and school were built on it in 1854 and 1858 respectively.

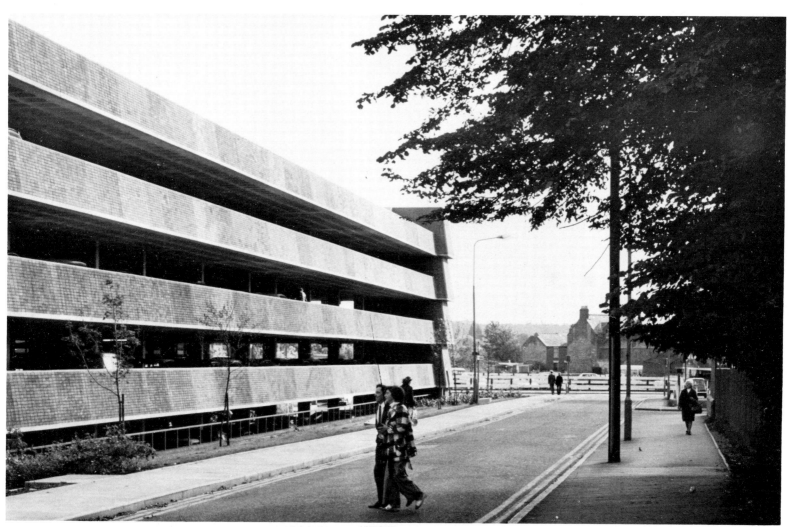

Paradise Square - 1975
The east side of the Square was demolished in 1971 to make way for the Westgate multi-storey car park, built between 1973 and 1974. This functional and not unattractive building provides spaces for 1028 cars, and was faced with brick-cladding to match the rest of the Westgate development.

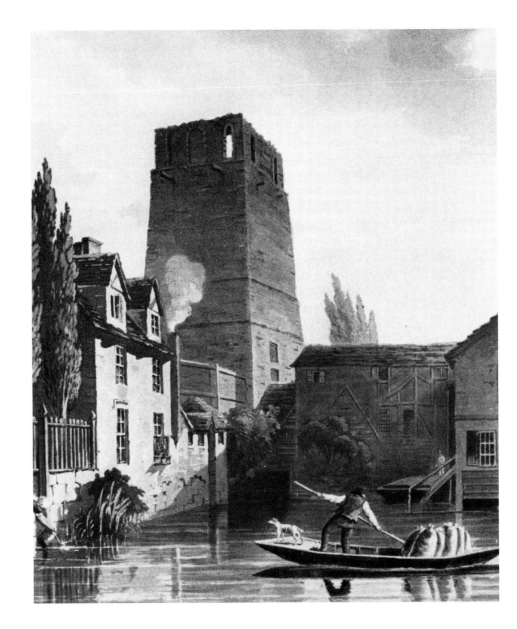

Oxford Castle - 1814

This engraving by Ackermann shows St. George's Tower, built in about 1071, and the adjacent mill which was probably working before 1086. To the left of the picture, a woman can be seen filling a jug from the Castle Mill Stream, no doubt a common sight in an area where most people relied on wells or streams for their water.

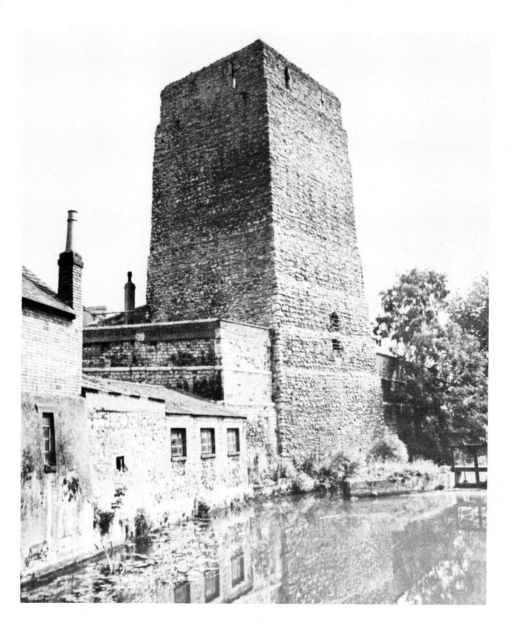

Oxford Castle - 1975
Although St. George's Tower survives, the Castle Mill was demolished in 1930 in order to widen Paradise Street. The two separate streams which turned its water-wheels are still visible, however, the one on the left having been cut in the late sixteenth century to give the mill more capacity.

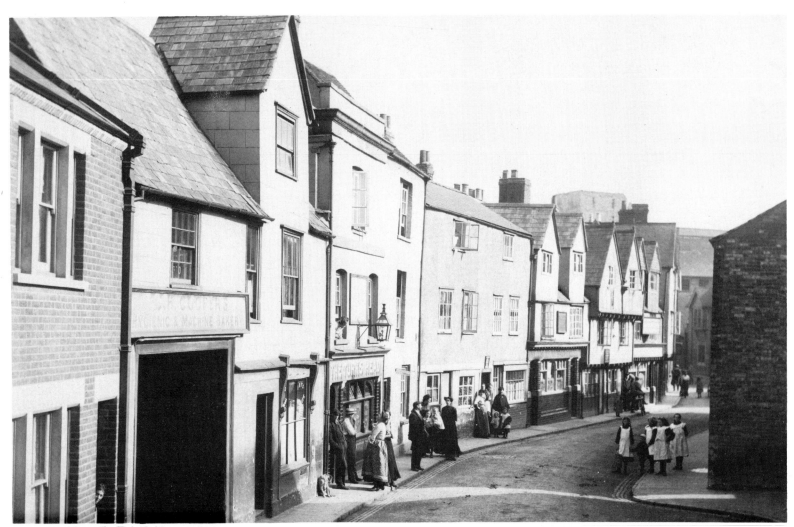

St. Thomas' Street - 1907
Fascinated, perhaps, by the rare appearance of a photographer in St. Thomas's, groups of adults and children gather in a street which still retained several seventeenth-century houses. Behind the street front, where there were numerous pubs and lodging houses, rows and courts provided congested accommodation for many families.

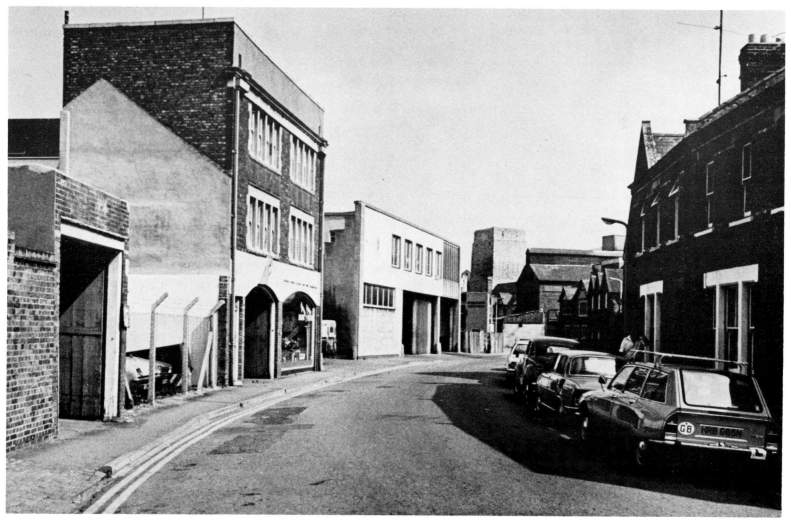

St. Thomas' Street - 1975
The last of the street's seventeenth-century houses were demolished in 1962, and the area still awaits redevelopment of a positive kind. At the far end of the street, the Victorian buildings of Morrell's Brewery maintain a link between brewing and St. Thomas's parish which goes back seven hundred years.

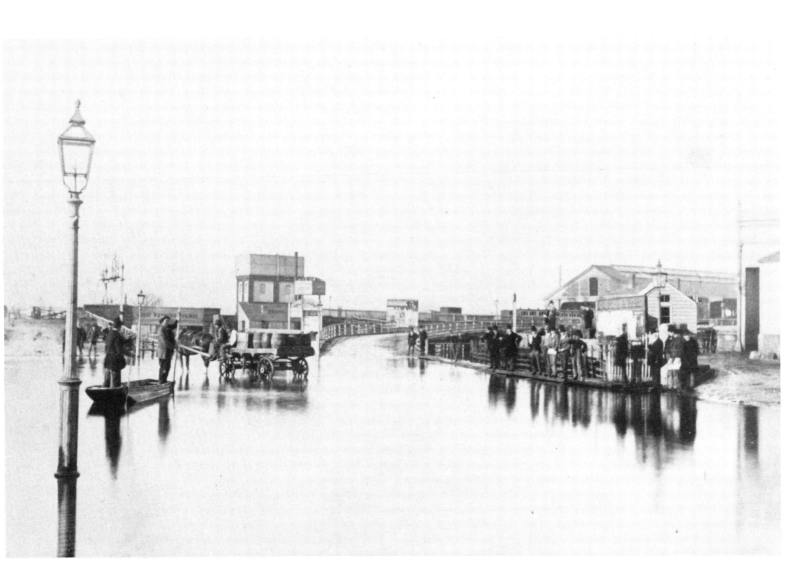

Oxford Stations from Park End Street - 1875
Beyond the flooded street, with its enterprising ferryman, an approach road leads up to the Great Western Railway Station of 1852. Part of the London and North Western Railway Station (1851) is visible on the right.

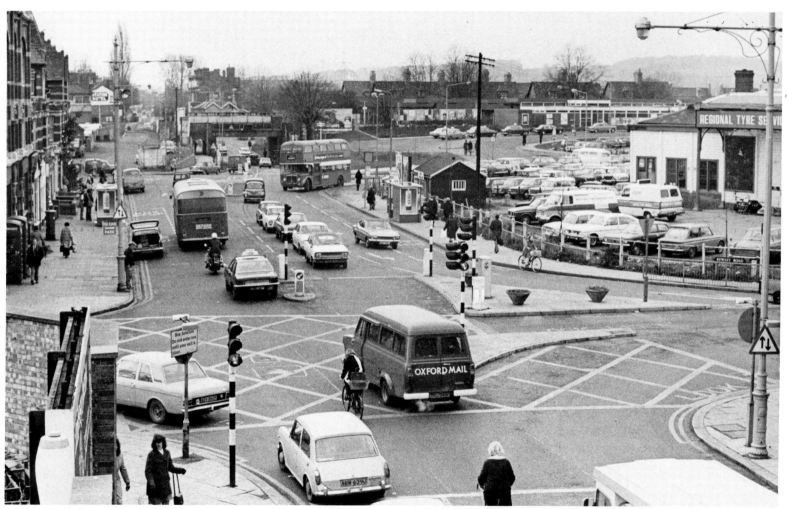

Park End Street - 1975
A hundred years later, the street is beset by the daily ebb and flow of traffic, and it is perhaps appropriate that the former LNWR and LMS Station should have become a tyre depot. The old GWR Station, which 'does yet whisper to the tourist the last enchantments of the Middle Ages', gave way to an economy-minded British Rail building in 1971-2.

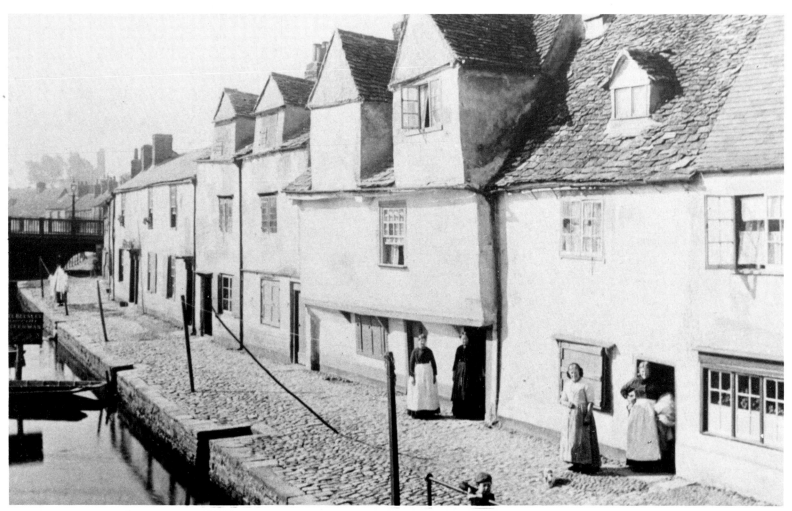

Middle Fisher Row - c. 1885
There is almost a Hollywood quality about this view of womenfolk standing on a cobbled quay outside picturesque seventeenth-century houses, but the little community was real enough. Abel Beesley, University Waterman, offered fish and bait for sale, baskets were made from locally-grown osiers, and punts were hired out from nearby Upper Fisher Row.

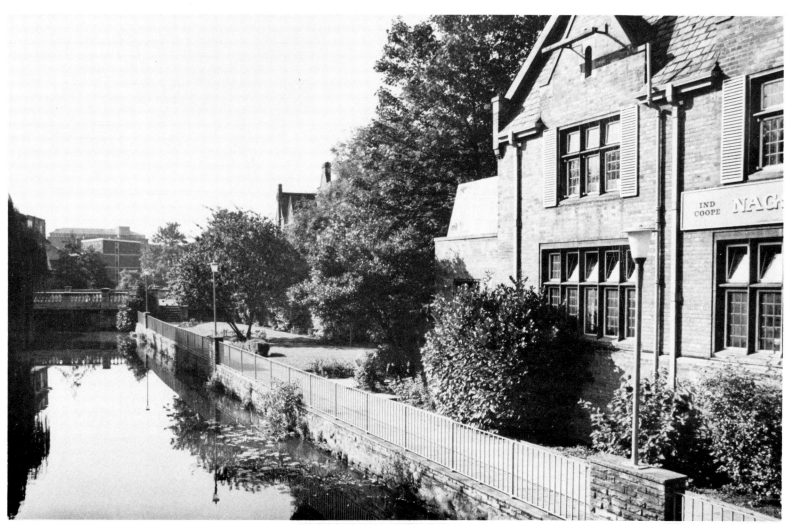

Middle Fisher Row - 1975
The Nag's Head was rebuilt in 1939, and surviving parts of the Row were demolished in 1954. Beyond what is now an attractive garden, Pacey's Bridge was reconstructed in about 1925, and the pedestrian now has to cross the street instead of walking under it.

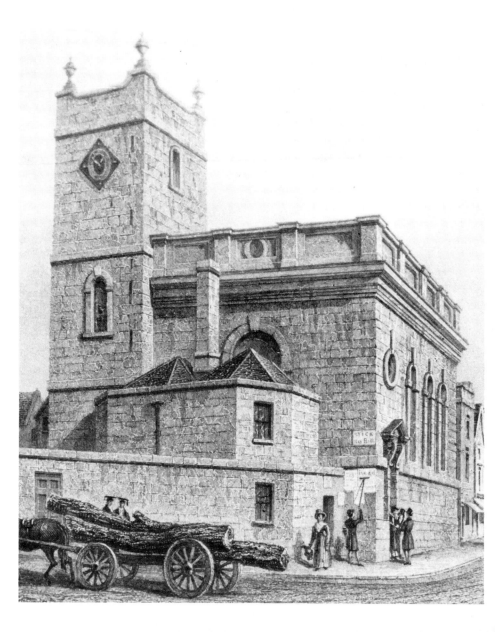

St. Peter Le Bailey old church from Castle Street - 1835

The medieval church fell down in 1726 and was replaced by this tall Georgian preaching house. In Le Keux's engraving, it is amusing to note that directly beneath the notice 'Stick No Bills', a man is busily pasting one to the church wall.

61

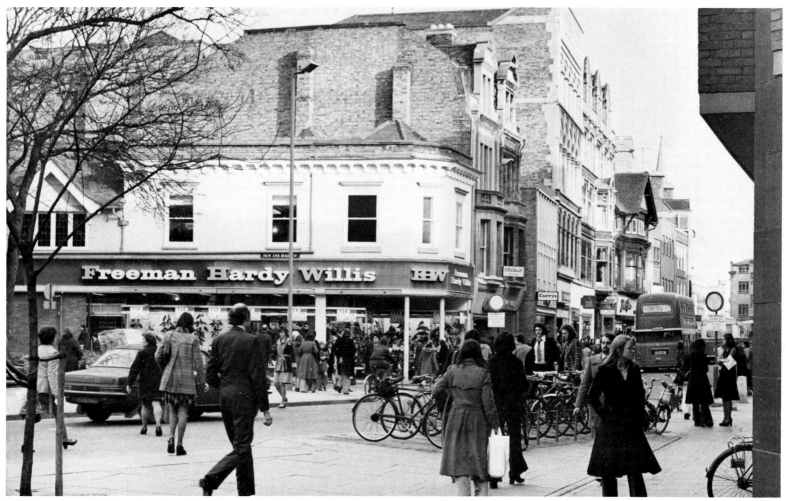

Bonn Square - 1975

By the 1870s, St. Peter Le Bailey church was regarded as a traffic hazard, and few tears were shed over the demolition of an unfashionably classical building in poor structural condition. A new church was built in New Inn Hall Street (1874, B. Champneys), and part of the old churchyard became a public garden. The road in front of it was re-named Bonn Square in 1974 in honour of the Oxford-Bonn link.

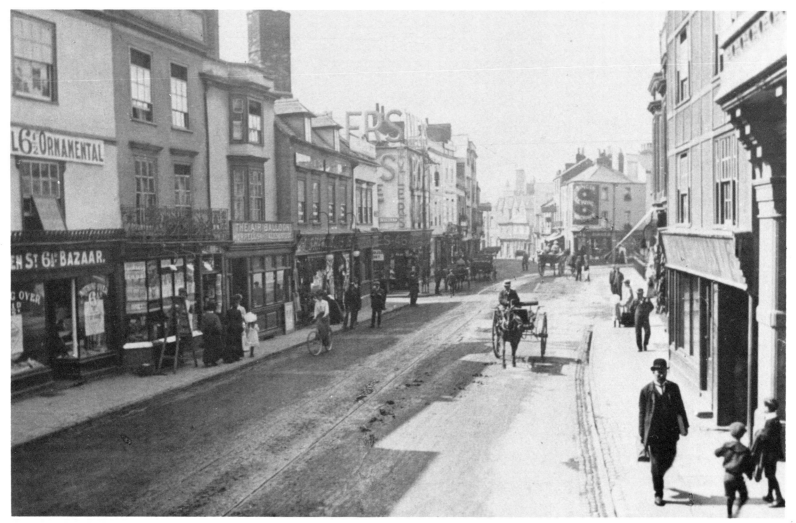

Castle Street from Queen Street - 1907
The commercial side of Oxford, with the Queen Street 6½d Bazaar and the massive advertising letters of Tyler's Boot Warehouse prominent. The Air Balloon pub, with its early nineteenth-century front, may have been re-named in honour of James Sadler (1751-1828), England's pioneer aeronaut and an Oxford man.

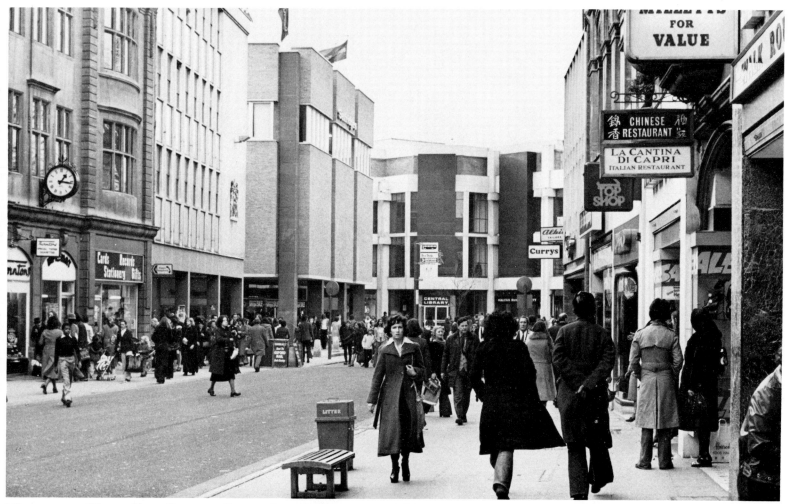

Westgate Shopping Centre from Queen Street - 1975
Castle Street was re-aligned during the Westgate development (1969-73), and the Central Library now stands across its site. The neo-classical building with the clock (1914, Wilkins and Jeeves) was built as offices for Hall's Oxford Brewery Ltd., but is now combined with the modern office block next door as City Chambers. Queen Street became a pedestrian precinct in 1970.

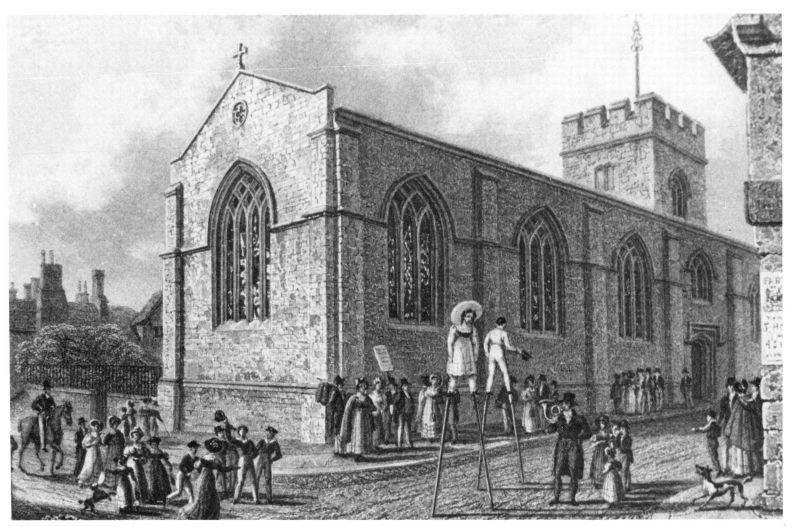

St. Ebbe's Church from the north-east - 1835
Mackenzie's drawing shows the church after its rebuilding in Gothic style by W. Fisher (1814-17). Adults and children have gathered round a man and woman on stilts, and a poster on the right was probably advertising a fast $5\frac{3}{4}$-hour coach service to London.

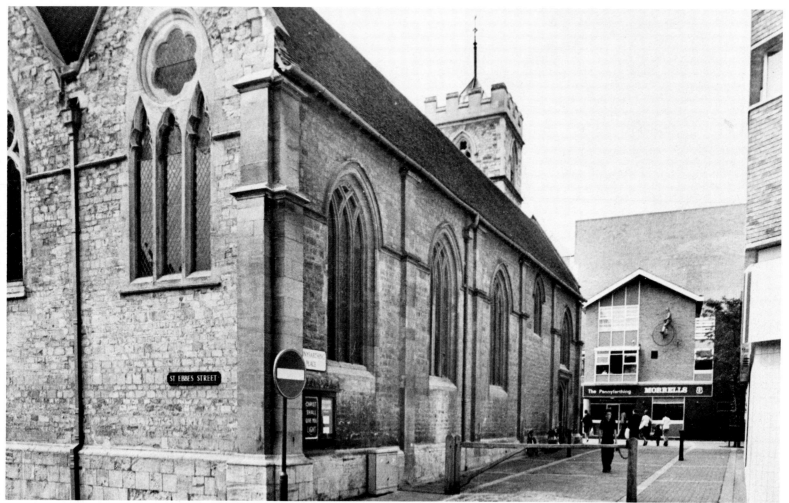

St. Ebbe's Church - 1975

A south aisle was added to the church (1862-6, G. E. Street), but the rest of the building has been little altered. Church Street was obliterated by the Westgate development, but the stub of it was re-named Pennyfarthing Place after a city bailiff of that name recorded in 1238. The new pub has up-dated the image somewhat by affixing a penny-farthing bicycle to the wall.

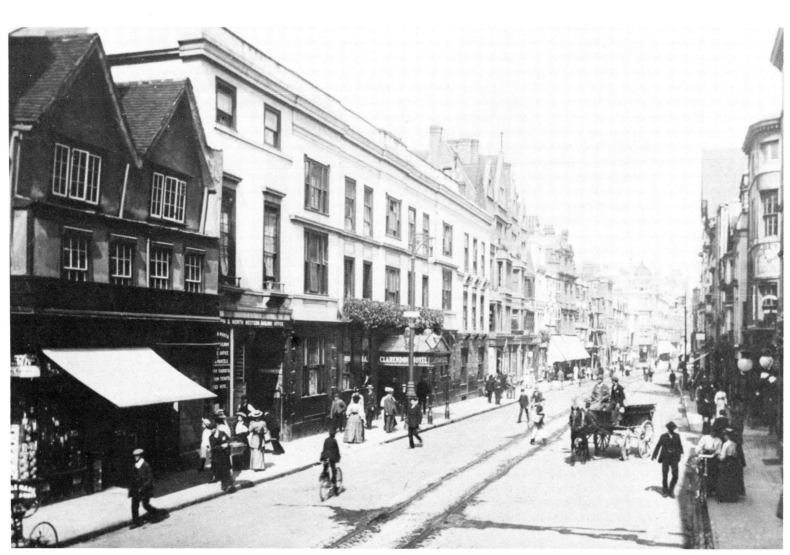

Cornmarket Street, looking north - 1907
Before the arrival of the chain stores, Cornmarket Street was full of architectural variety, and dominated by the unexceptional, but pleasing, nineteenth-century facade of the Clarendon Hotel.

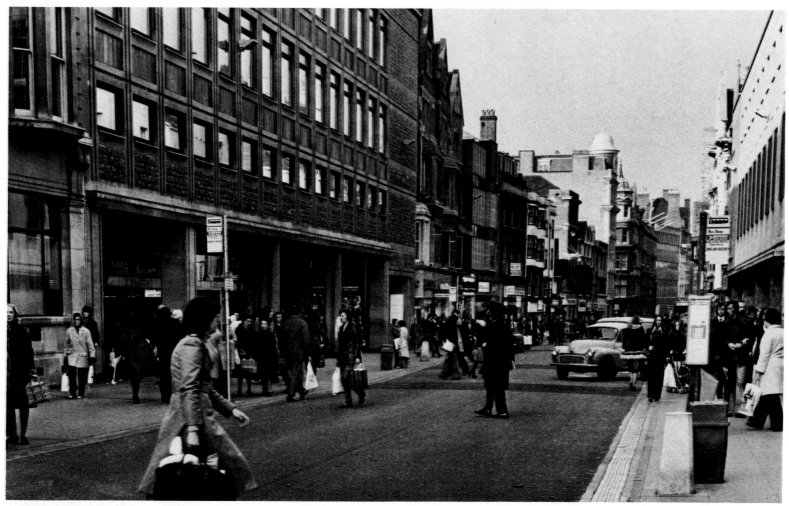

Cornmarket Street - 1975

After much post-war controversy, the Clarendon Hotel was demolished in 1954, and replaced by Lord Holford's Woolworth's building (1956-7). Marks and Spencer built the block north of Market Street in 1963, and the pedestrian was given more opportunity to appreciate these changes in 1973, when most traffic was excluded from the street.

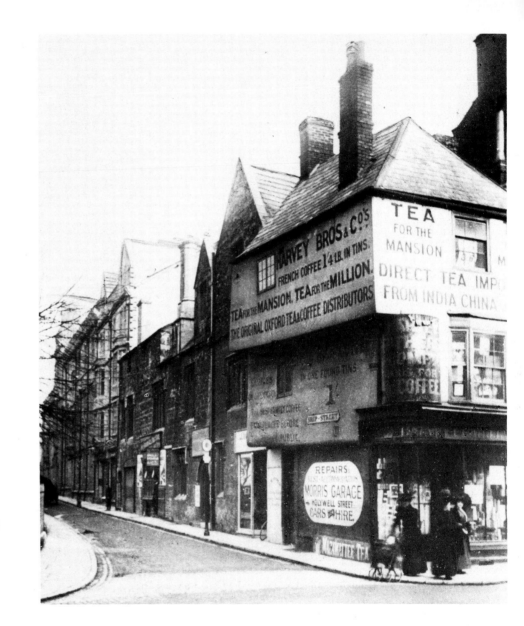

Cornmarket Street and Ship Street - 1911

A medieval house acted as an advertisement hoarding for Harvey Bros., who modestly offered 'The Best Family Coffee Ever Placed Before The British Public'. The post topped by a white circle in Ship Street advised motorists of the 10 m.p.h. speed limit in Cornmarket Street imposed the previous year.

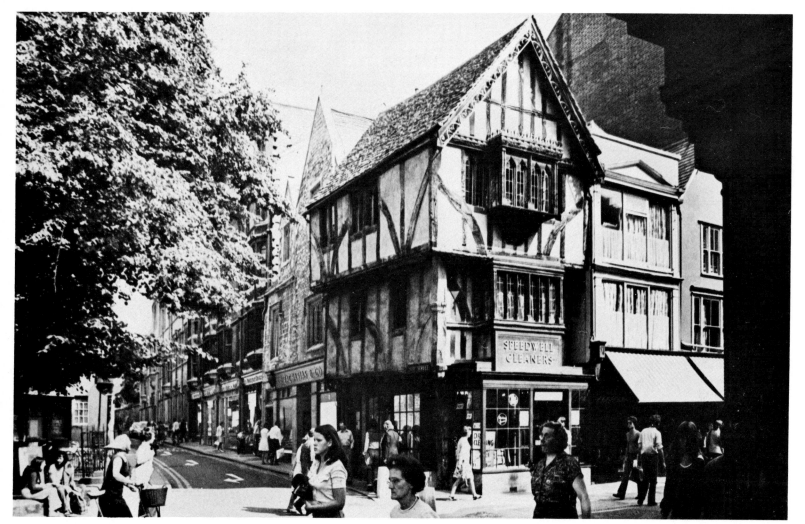

Cornmarket Street and Ship Street - 1975
The fifteenth-century facade of no. 28 Cornmarket Street was uncovered and partially reconstructed in 1952, but the adjoining properties, which include a fifteenth-century stone house with seventeenth-century gables, have not been altered.

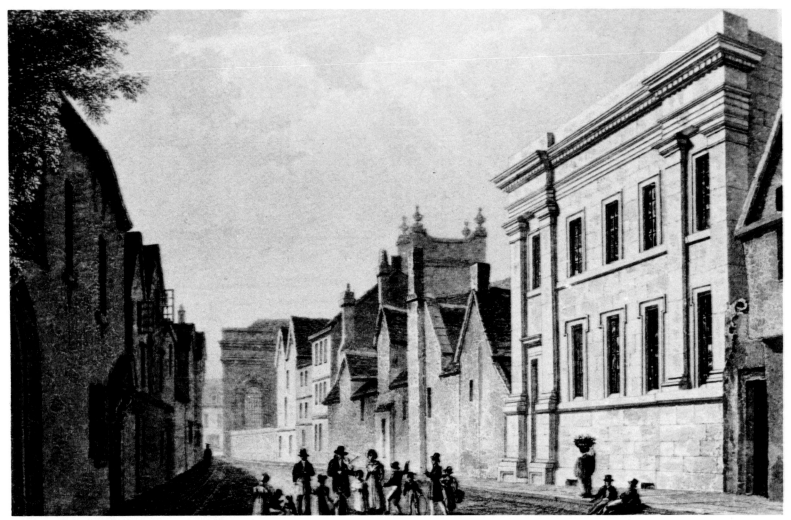

New Inn Hall Street - 1836
Le Keux's engraving shows children dancing round a street musician. Away to the left, the fifteenth-century gateway of Frewin Hall, formerly St. Mary's College, is visible, and on the right, Hannington Hall (1832, Thomas Greenshields) had just been built amidst seventeenth-century houses.

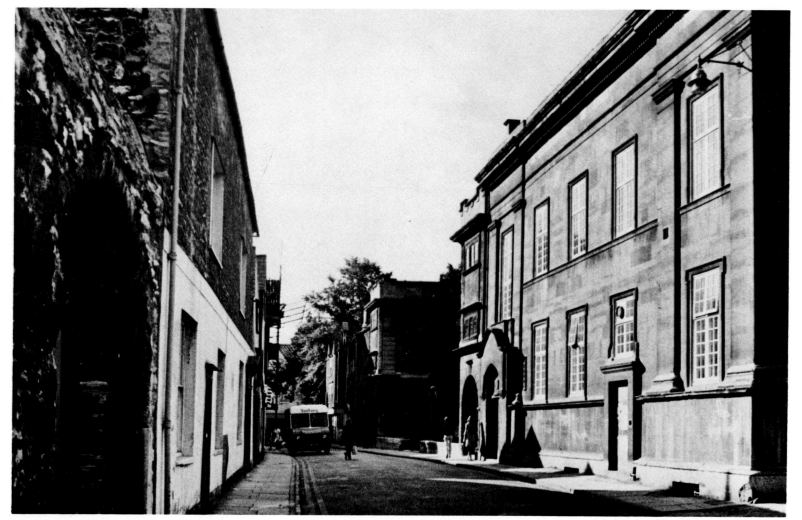

New Inn Hall Street - 1975
Frewin Hall and, beyond it, the house where John Wesley preached in 1783, both survive. On the right, Hannington Hall was altered in 1897-8, and the former Girls' Central School (1901, Leonard Stokes) stands to the south of it.

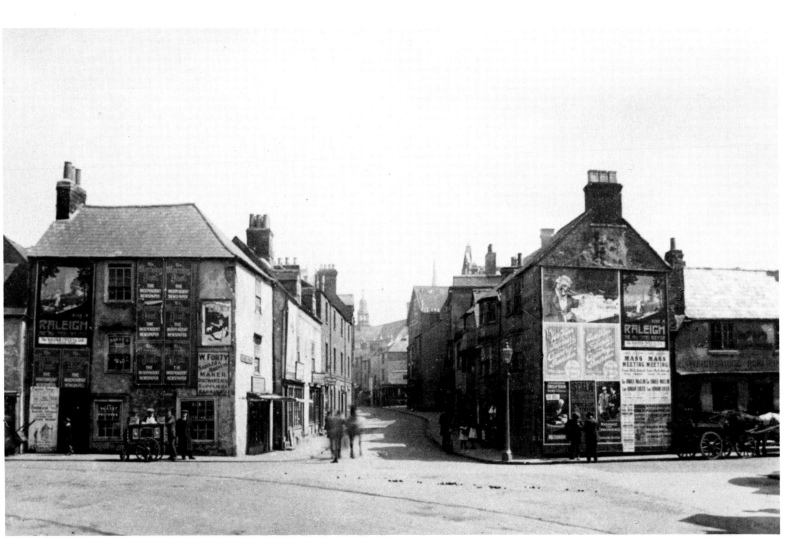

George Street from Hythe Bridge Street - 1920
An ice-cream cart stands outside the run-down premises of W. Forty, saddler and harness-maker. Most of the properties in the area had been built or adapted in the early nineteenth century, and hoardings advertising everything from blotting paper to political meetings only served to emphasise the fact that they had seen better days.

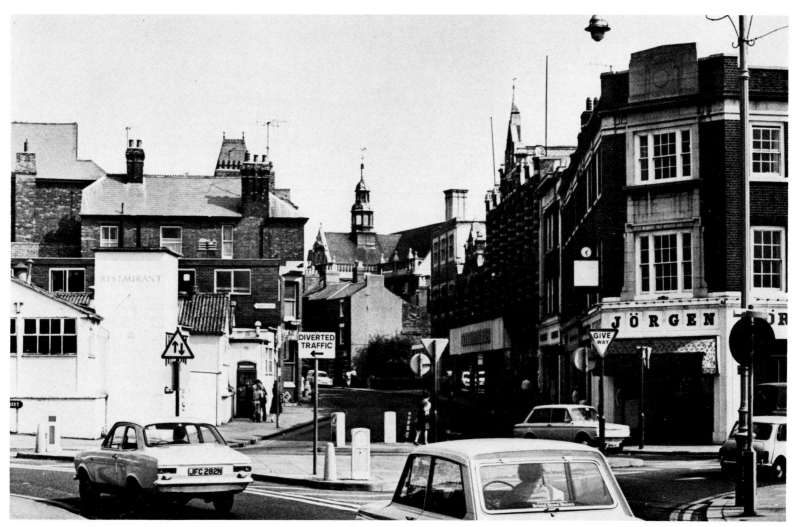

George Street - 1975
One of the city's war-time Municipal Restaurants, and the only one still in use, replaced Forty's, and all the other buildings up to Chain Alley have now been redeveloped. On the right, the lower end of George Street was widened and rebuilt in the 1920s, and the modern picture is completed by an assortment of traffic signs.

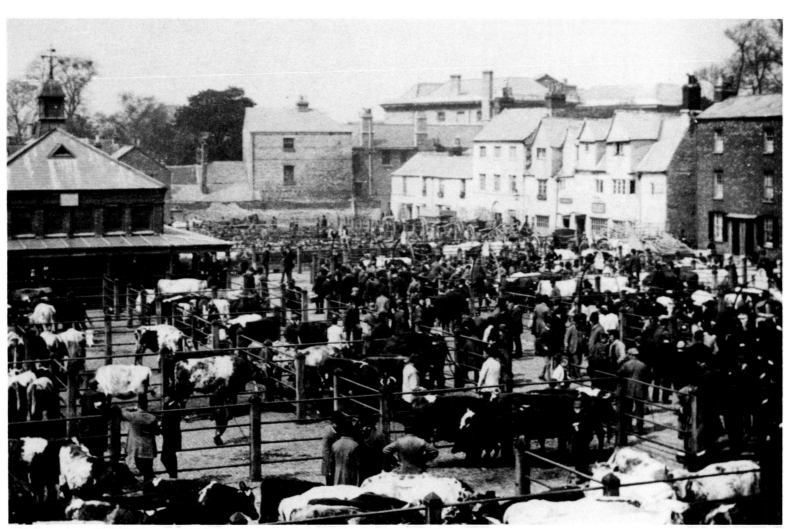

Gloucester Green - c. 1900
The city obtained a charter to hold a cattle market here in 1601, but the market-place was only laid out in this form with permanent pens and a settling room in 1881. Beyond the sheep and cattle, seventeenth-century gabled houses had existed since the Green's heyday as an open space surrounded by trees.

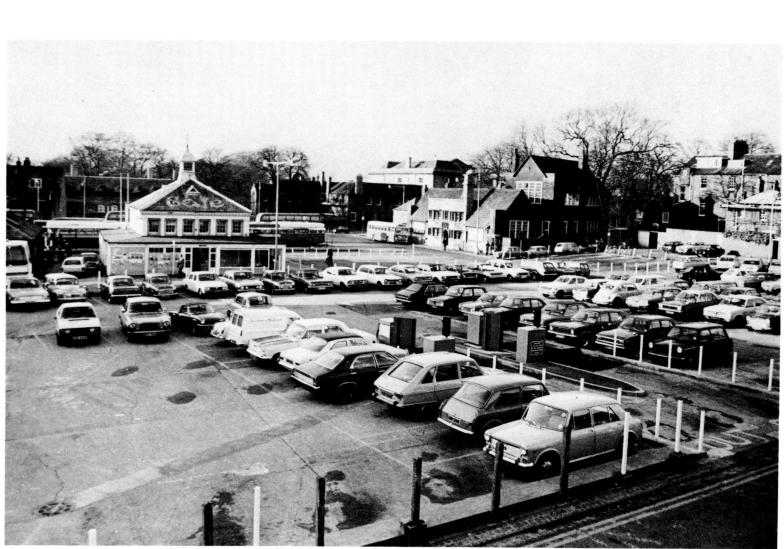

Gloucester Green - 1975
The Green became a bus station and car park after the removal of the cattle market to the Oxpens in 1932. The former settling room and the Central Boys' School (1901, Leonard Stokes) survive as cafe and bus station offices respectively, but most of the older properties have now been demolished.

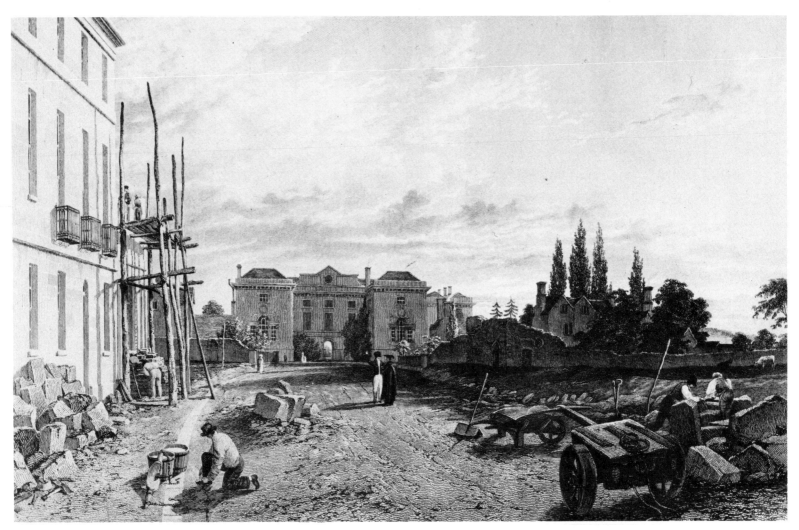

Beaumont Street and Worcester College - c. 1824
Hollis's engraving shows the facades of the Beaumont Street houses under construction, and, to the right of Worcester College front, the ruins of Beaumont Palace, birthplace of Richard I and possibly King John. By the scaffolding, a man has put down his yoke while he ties his shoe-lace.

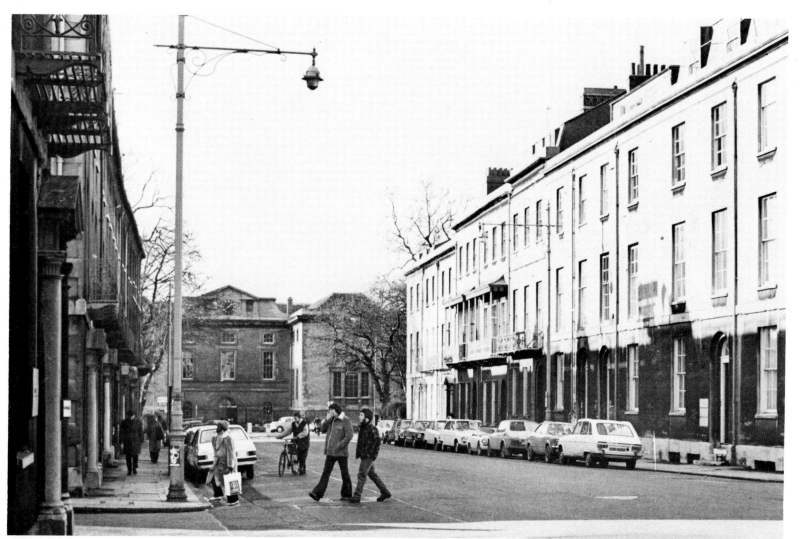

Beaumont Street - 1976
The street was completed by 1838, and the west end looking down towards Worcester College has changed little since then. Most of the houses have now been converted into offices or surgeries.

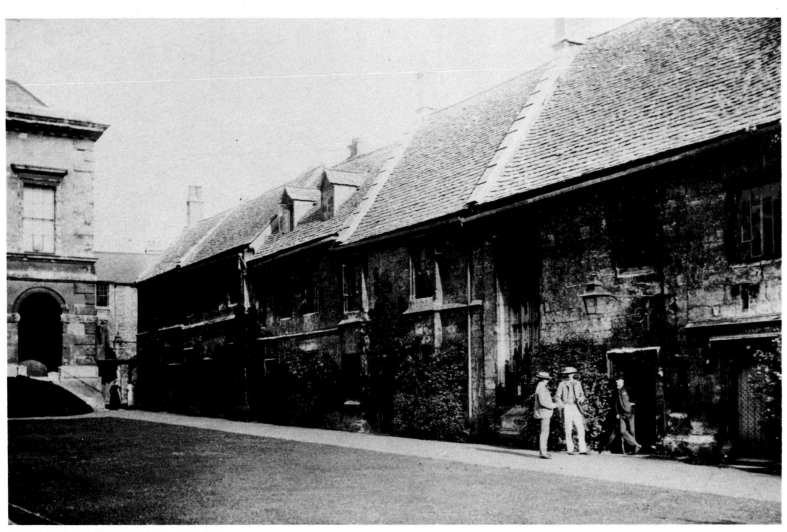

Worcester College - c. 1880
This photograph shows the fifteenth-century south range of Gloucester College, where each staircase was the responsibility of a Benedictine monastery from the Province of Canterbury. The College was re-founded as Gloucester Hall in 1541, and again as Worcester College in 1714.

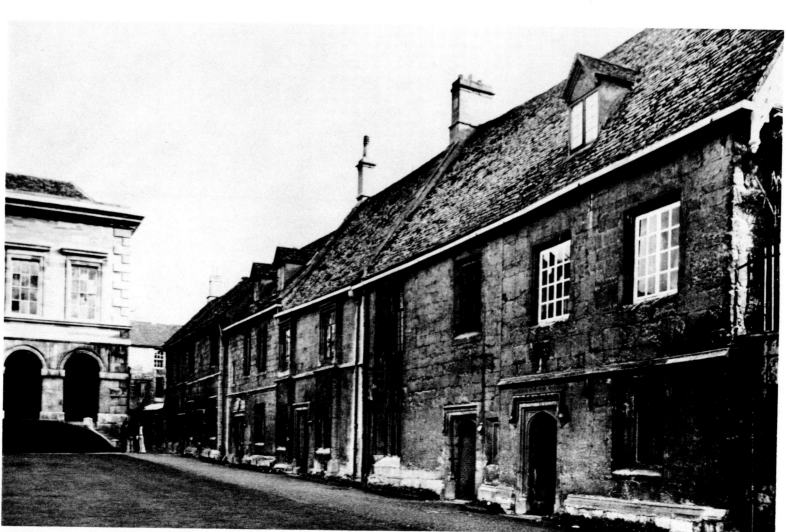

Worcester College - 1976
The south range survived eighteenth-century rebuilding plans through lack of money, and twentieth-century expansion has taken place farther south. Only the dress of the undergraduates gives away the fact that nearly a hundred years separate these two photographs.

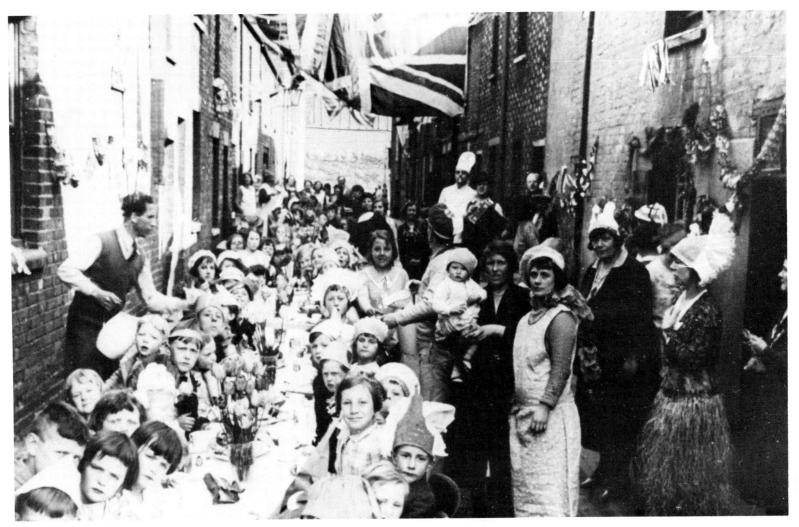

King Street, Jericho - 1935
A street party to celebrate the Silver Jubilee of George V with one mother in exotic Hawaiian costume, and children enjoying tea and cakes. The dark and narrow street laid out in the 1830s provided no barrier to the enjoyment of this special occasion.

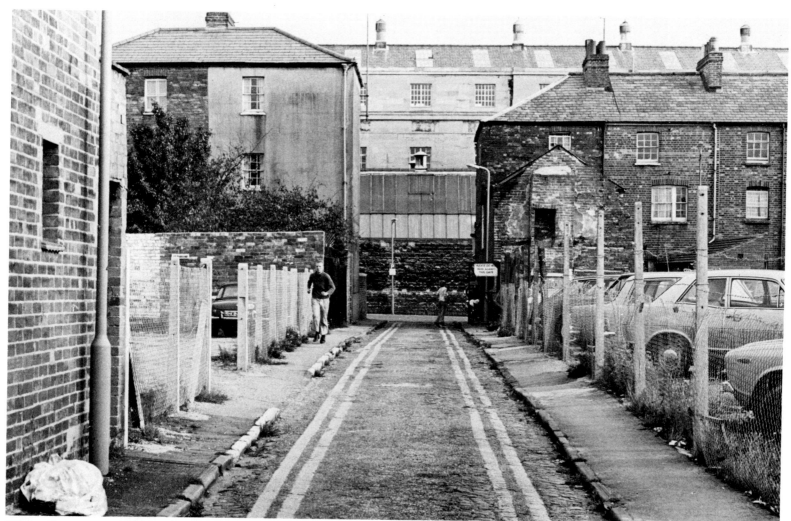

King Street - 1975
A vanished community where cars now park behind chain-link fencing. At the end of the street, tall houses from approximately 1830 still survive opposite the building of the Oxford University Press which hastened the growth of this area.

Woodstock Road - 1892
Beaters of the city's boundaries stroll boldly up the middle of a quiet main road. At this point, North Oxford was still almost rural, although the walls of private estates, and a single house away in the background, are a reminder that development was spreading ever nearer.

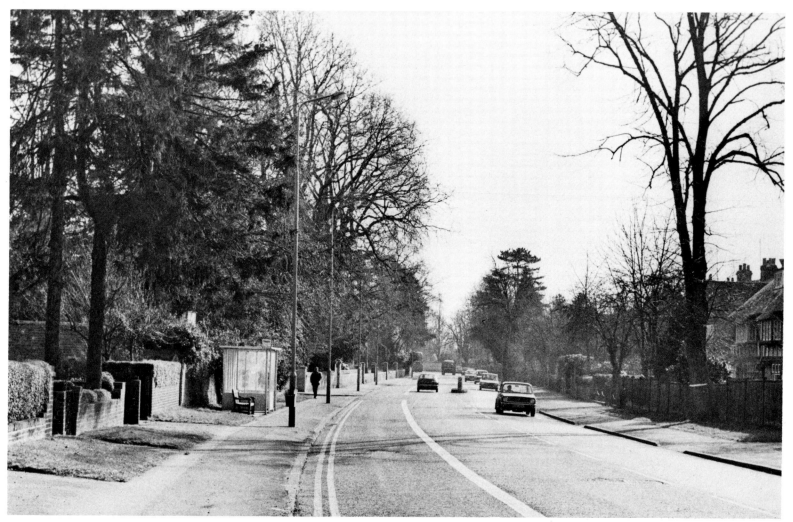

Woodstock Road - 1976
The area was engulfed by housing in the 1920s, and any modern beaters of the Bounds would have to keep to the pavement if they valued their lives. On the left, the walls of nos. 304 and 306 Woodstock Road have survived the passage of time.

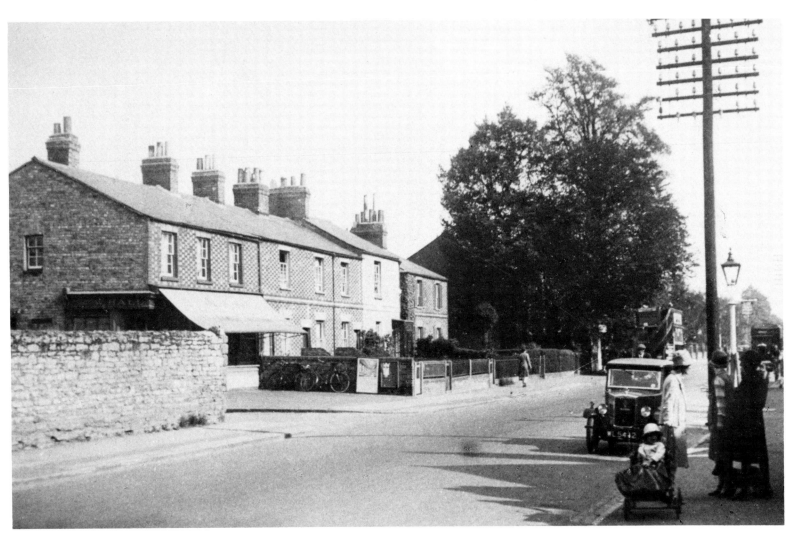

Banbury Road, Summertown - 1929
Here we see diaper brick, two-storey houses of the 1820s, dating back to the earliest years of this little village outside Oxford. The name Summertown is ascribed to James Lambourn, a horsedealer, who christened the place Somer's Town because of its pleasantness.

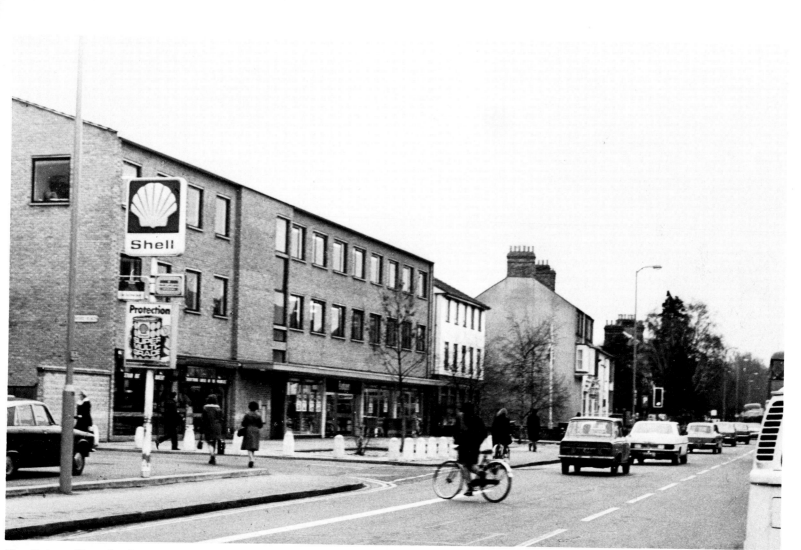

Banbury Road, Summertown - 1975
Summertown shopping centre altered the east side of Banbury Road beyond recognition during the 1960s, replacing small houses with modern shops and offices. Earlier buildings hidden behind a tree in the previous picture do survive, however, and are now more prominent.

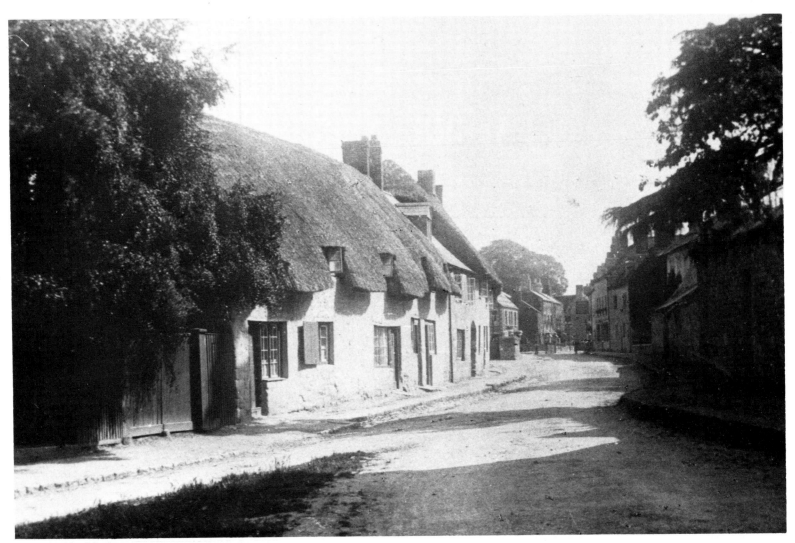

Church Street, Headington - 1915
A row of seventeenth-century thatched cottages built of local rubble stone formed an attractive approach to St. Andrew's Church and the centre of Old Headington.

87

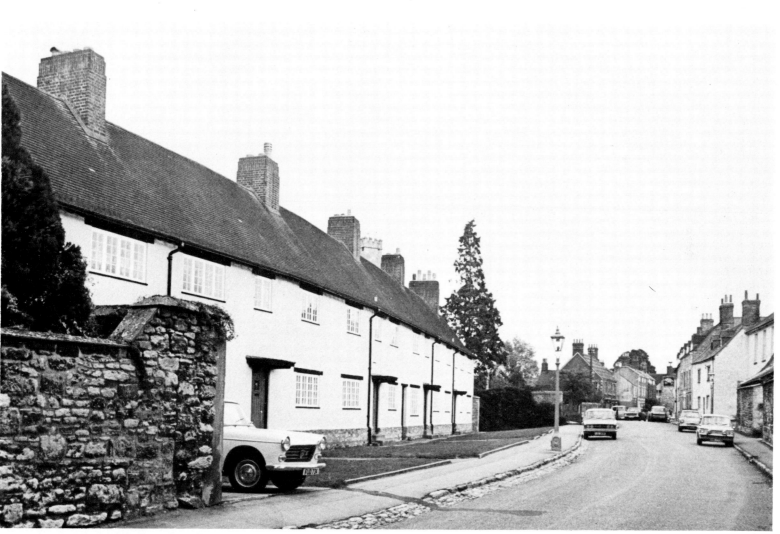

St. Andrew's Road, Headington - 1975
The old cottages were pulled down in 1937 as part of a slum clearance scheme after their restoration had been judged impossible. The Oxford Preservation Trust built the row which replaced them, and would have thatched the new houses if permission had been forthcoming. The street name was changed in 1955.

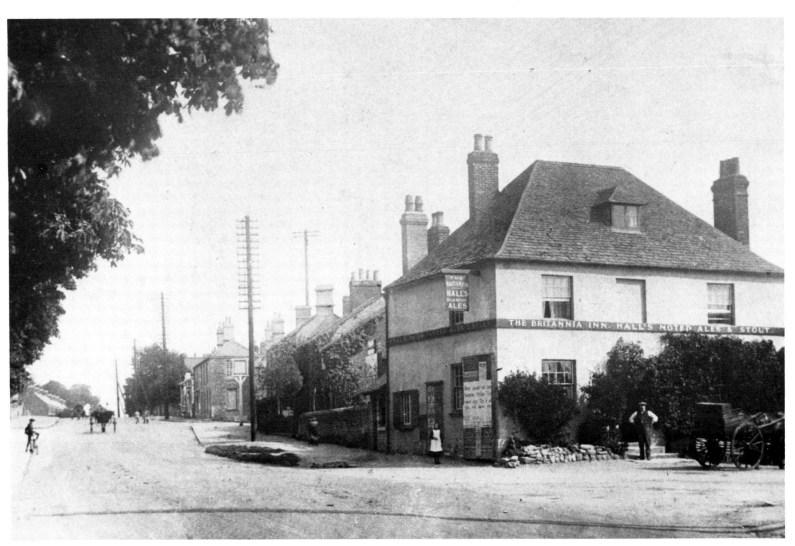

London Road, Headington - 1915
J. Sainsbury's delivery van stands outside the eighteenth-century Britannia, which was probably built as a wayside inn after London Road replaced Old Road as the main Oxford-Wheatley-London turnpike road in 1771.

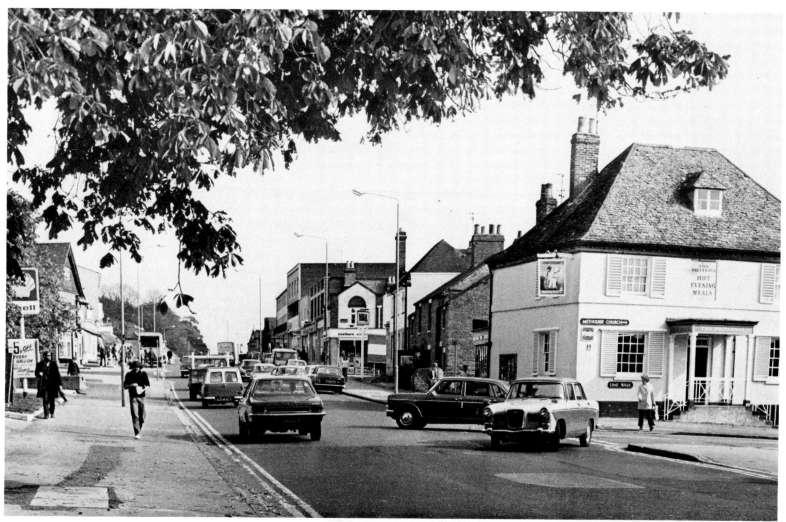

London Road, Headington - 1975
The Britannia still flourishes, but the Headington shopping centre has spread west from Headington Carfax, causing many of the older properties to be converted into shops, or replaced. The same horse chestnut tree now overshadows a much busier road.

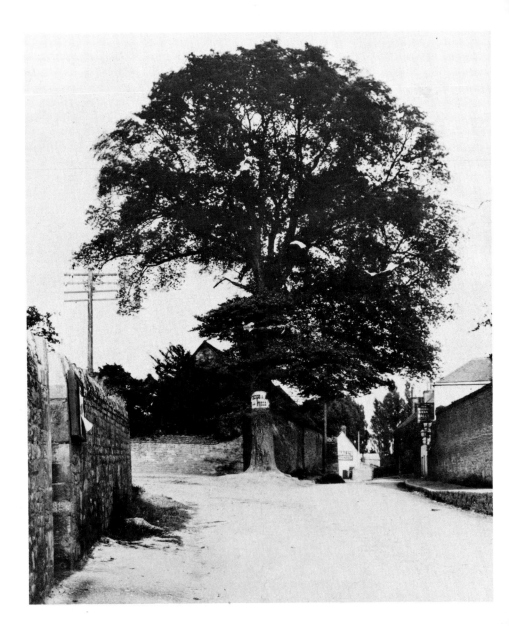

Oxford Road and the Stocks Tree, Cowley - 1908

The tree bears a poster directing the visitor along Temple Road to the Church Army Press, which was established in an old Congregational Church in about 1900. A narrow Oxford Road leads up between The Original Swan and White's Farm to the Waggon and Horses public house.

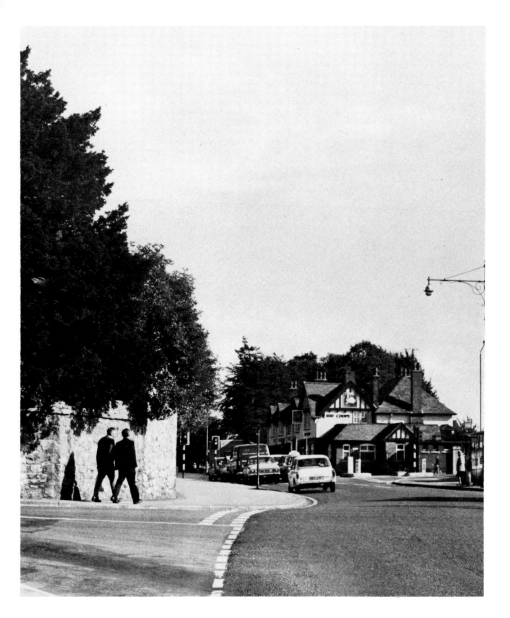

Oxford Road, Cowley - 1975
The wall of White's Farm remains, but the surviving farm buildings were demolished in about 1957. Oxford Road has been much widened, and The Original Swan, rebuilt in the 1920s in Tudorbethan style, stands beyond Between Towns Road, where the Waggon and Horses used to be.

92

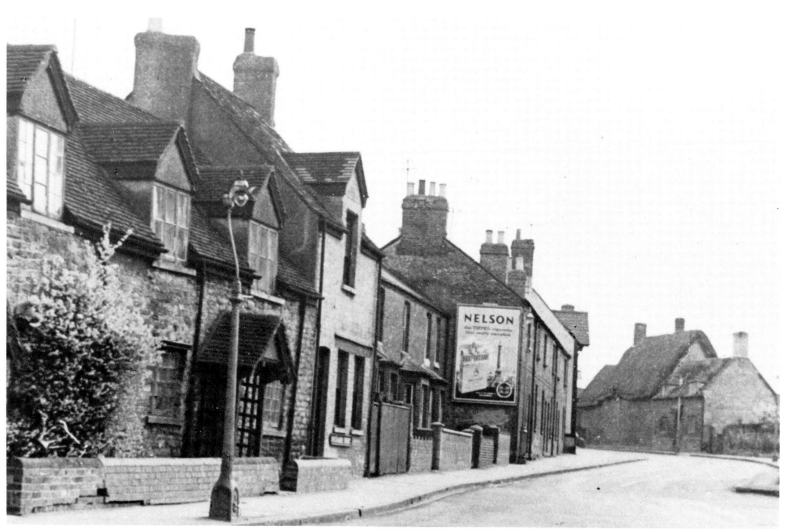

Hockmore Street, Cowley - 1960

In spite of the massive expansion of Cowley and Lord Nuffield's factories between the wars, the village centre remained substantially intact with numbers of thatched and local stone houses dating back to the seventeenth and eighteenth centuries.

93

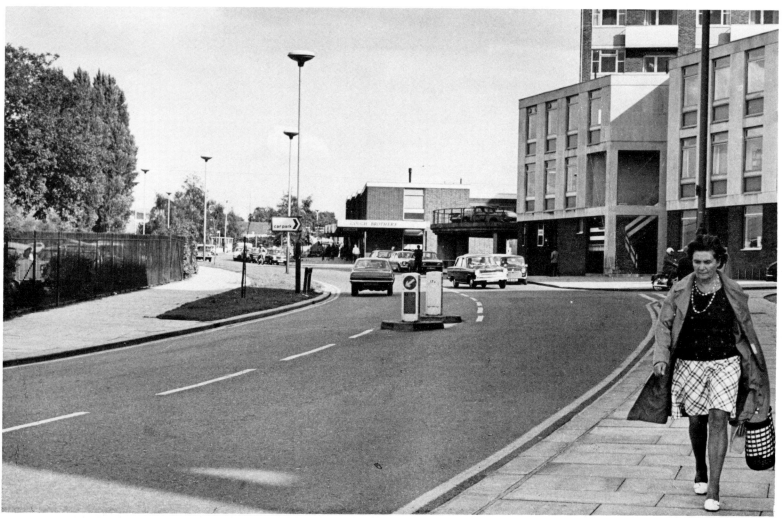

Between Towns Road, Cowley - 1975
Shopping facilities in Cowley did not keep pace with the growth of population, and in order to provide an alternative to the congested city centre Cowley Centre was built between 1961 and 1965. Old Hockmore Street disappeared, but the name lingers on in a service road behind the Centre.

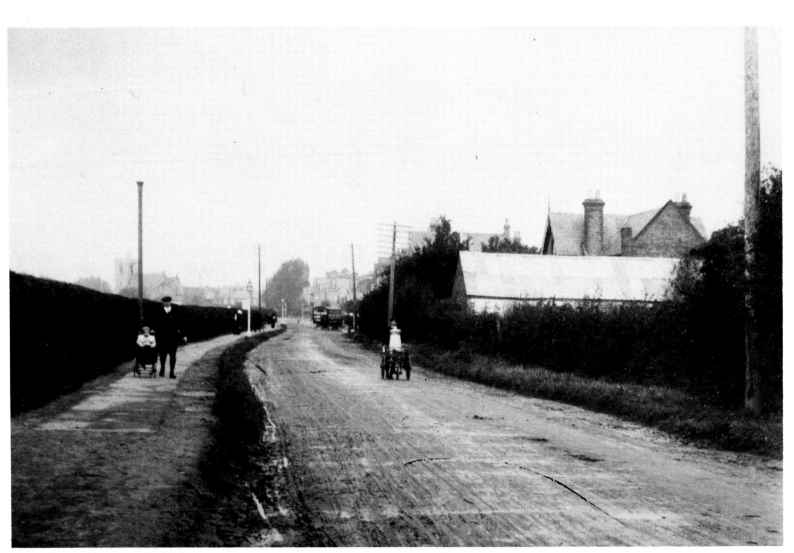

Cowley Road, looking west to St. Mary and St. John Church - 1917
At this date, Cowley Road still retained the peace and quiet of a country lane, and the only traffic visible consists of a man pushing a milk-cart and, in the distance, a horse-drawn Pickford's van.

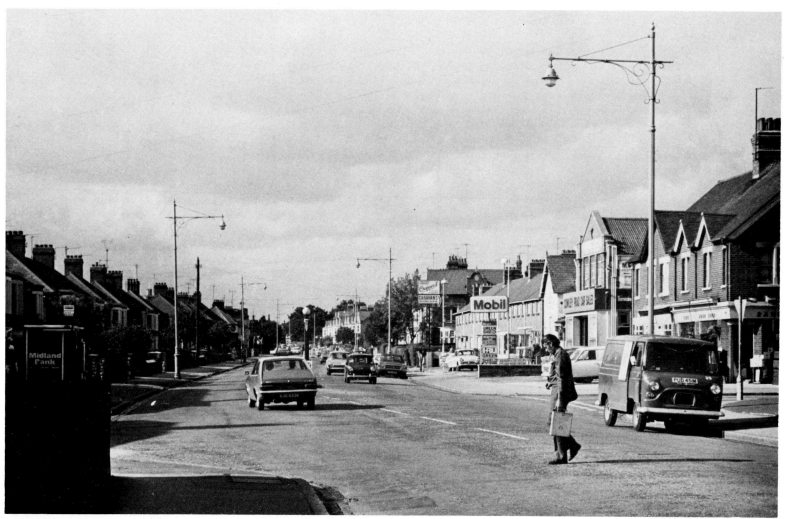

Cowley Road - 1975
Housing development in the 1920s blotted out most of the church, although the top of the tower is just visible between chimneys. On the right, gaps between houses have been filled, and the gabled house, which stood behind a corrugated iron shed in the previous picture, survives beyond Cowley Road Car Sales.

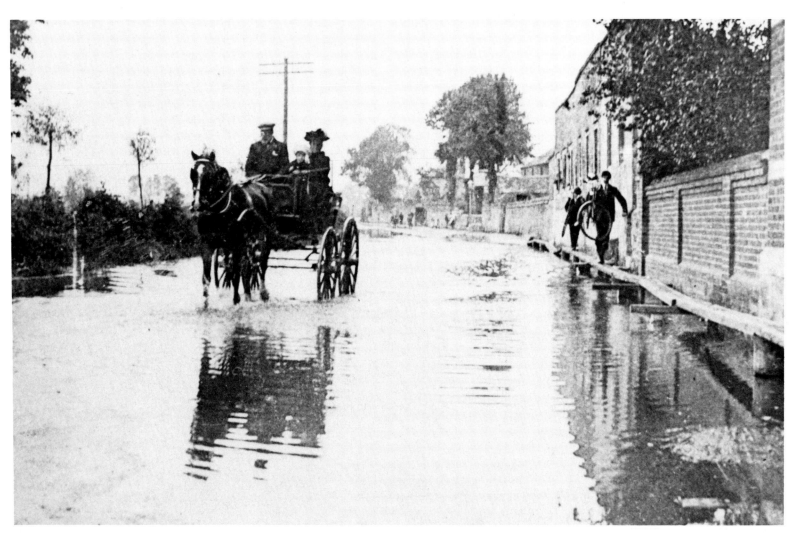

Abingdon Road - 1894
This photograph shows Coldharbour at flood-time with cyclists walking the plank outside the Salt-boxes, remarkable single-storey houses built early in the nineteenth century. A milestone is visible outside the nearest house, and the brick wall on the right marks the boundary of the city's Infectious Diseases Hospital built in 1886.

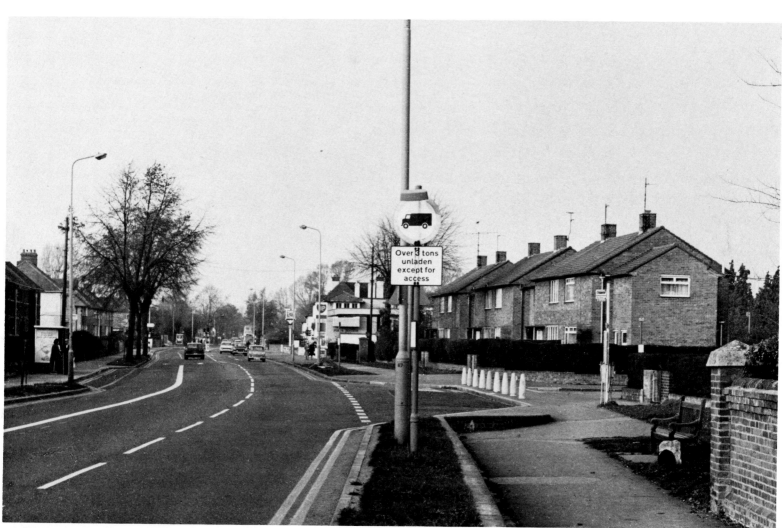

Abingdon Road - 1975
Oxford spread south from New Hinksey in the 1920s and 1930s, and all the older houses in Coldharbour have disappeared. The hospital survives as Rivermead Hospital, and beyond its wall the milestone has been re-set on the grass verge.